Lettering Alphabets & Artwork

Inspiring IDEAS & TECHNIQUES for 60 HAND-LETTERING STYLES

By: JAY ROEDER

UNION SQUARE & CO.

NEW YORK

UNION SQUARE & CO.

NEW YORK

UNION SQUARE & CO. and the distinctive Union Square & Co. logo are trademarks of Sterling Publishing Co., Inc.

Union Square & Co., LLC., is a subsidiary of Sterling Publishing Co., Inc.

© 2022 Blue Red Press Ltd

All rights reserved. No part of this publication may be reproduced, stored in a retrieval system, or transmitted in any form or by any means (including electronic, mechanical, photocopying, recording, or otherwise) without prior written permission from the publisher.

ISBN 978-1-4547-1091-2

For information about custom editions, special sales, and premium purchases, please contact specialsales@unionsquareandco.com.

Manufactured in India

4 6 8 10 9 7 5

unionsquareandco.com

Cover and interior design by Jay Roeder

Dedicated to my wife

TABLE OF CONTENTS

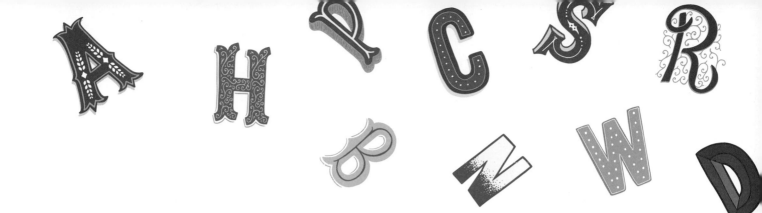

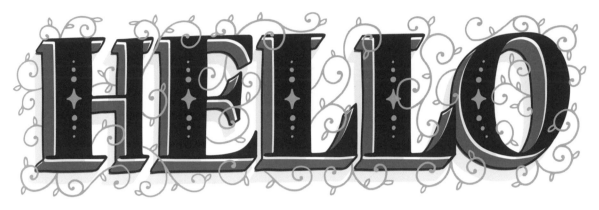

While most kids wanted to be firefighters or astronauts, I knew at a young age that I'd pursue a career in the arts. I created some of my earliest hand-lettering at age five: I would draw the Teenage Mutant Ninja Turtles and G.I. Joe logos on any piece of paper I could get my hands on, including homework from school. However, it wasn't until the late 2000s that I started to focus on hand-lettering as an isolated form of art. It started with lettering headlines for design concepts I worked on at various ad agencies. After a number of years at these agencies, I decided to go out on my own to focus on my hand-lettering passion—it is one of the best decisions I have ever made.

Even after all these years, I've never really stopped to think about why I am such an avid fan of hand-lettering. Maybe it's because lettering has the ability to reveal the hand of its creator. Each piece of artwork is one-of-a-kind, made for a specific project or application. Maybe it's because hand-lettering breaks the rules and is imperfect. Maybe it's the seemingly endless ways a single alphabet can be drawn. Or maybe it's the feeling I get when I finish a piece. Whatever the reasons, I love lettering and my passion for it has only grown over the years.

When I first started to take an interest in hand-lettering, there was little information about this art form readily available. I had to establish my own

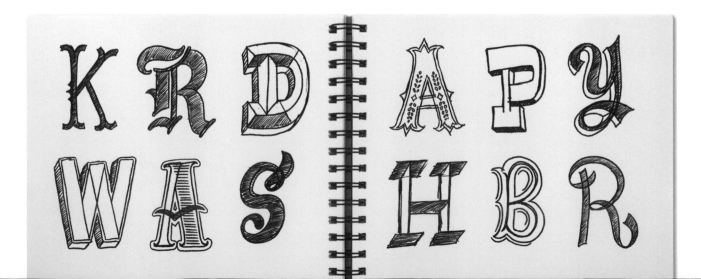

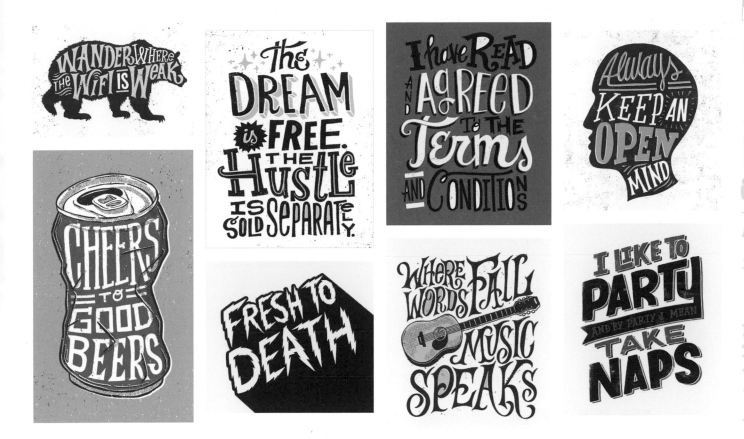

workflow based on trial and error—and use lots of sketchbook paper along the way! This led to the release of my first book *100 Days of Lettering*, which focused on teaching beginners how to letter over the course of 100 days. In this book, I push that idea even further and share some of my favorite alphabets and artwork to inspire lettering artists of all skill levels.

Throughout these pages, you'll find sixty hand-lettered alphabets broken down into four major categories: sans serif, serif, script, and decorative. Each section has a mixture of alphabet styles to fit any skill level. You will learn how letterforms are created and how an alphabetic style is used to inspire a lettering composition. Along the way, I share step-by-step guides to demonstrate how a finished piece comes to life. Each section also features a gallery of artwork from some of the most talented hand-lettering artists around the world.

I hope this book will help ignite your passion for lettering and inspire you to draw your own alphabets and artwork. With a little inspiration and practice, we all can create our own unique lettering. So grab a pencil and paper or a tablet and stylus, and start lettering today!

Jay Roeder

LETTERING STYLES

There are many different types of alphabets, but most can be classified into four basic styles: serif, sans serif, script, and decorative. From each of these categories, typographers, calligraphers, and hand-letterers have created many different subcategories. The classifications below will help you establish a basic understanding of how alphabets differ and what truly distinguishes them visually. It's essential to use this foundation when creating your own alphabets.

Serif alphabets are characterized by the small lines or flourishes at the end of each stroke in a letterform. Serif text is often considered easier to read, especially at smaller sizes, and is typically preferred when used in print.

SERIF STYLE EXAMPLES

ABC
Slab Serif

ABC
Bracketed Serif

ABC
Heavy Contrast Serif

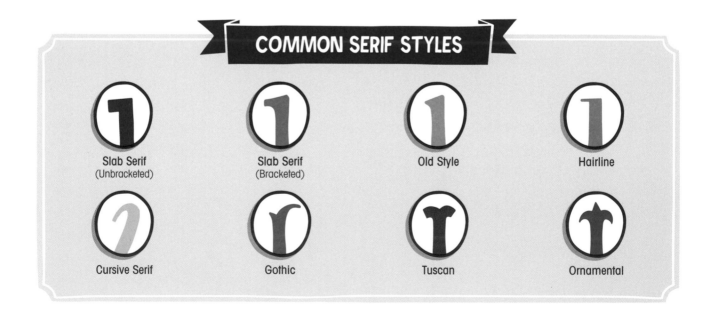

COMMON SERIF STYLES

Slab Serif (Unbracketed)

Slab Serif (Bracketed)

Old Style

Hairline

Cursive Serif

Gothic

Tuscan

Ornamental

SANS SERIF

"Sans" means "without" in French; therefore, sans serif alphabets lack embellishments on the ends of letterforms. This style takes on a simple shape and is often considered more modern than its serif counterpart.

SANS SERIF STYLE EXAMPLES

Grotesque

Geometric

Square

Script lettering derives from historical writing and printing styles. Many characters have strokes that join them to other letters, as seen in calligraphic, cursive, and brush alphabets. Script styles are unique and personal.

SCRIPT STYLE EXAMPLES

Cursive & Calligraphic

Blackletter

Brush

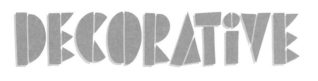

Decorative alphabets are typically used for titles and headlines because their distinctive features can interfere with legibility at smaller sizes. This style of lettering often uses unusual letterforms to achieve dramatic results.

DECORATIVE STYLE EXAMPLES

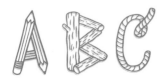

Representational

Freestyle

Graffiti

ANATOMY OF LETTERFORMS

Have you ever thought about what distinguishes one letter style from the next? In order to properly discern these differences, it's important to familiarize yourself with a standardized set of terms commonly referred to as the "anatomy of letterforms." Once you know how to visually deconstruct a letter, it will be much easier to understand how that specific letter or alphabet was built and, more importantly, how to create your own lettering styles. On these pages are a few of the more commonly used terms to help give you a crash course on letter anatomy.

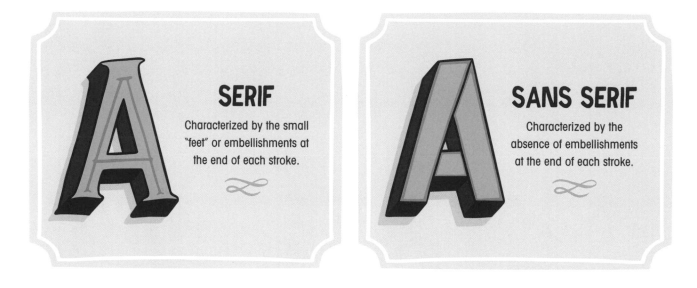

SERIF
Characterized by the small "feet" or embellishments at the end of each stroke.

SANS SERIF
Characterized by the absence of embellishments at the end of each stroke.

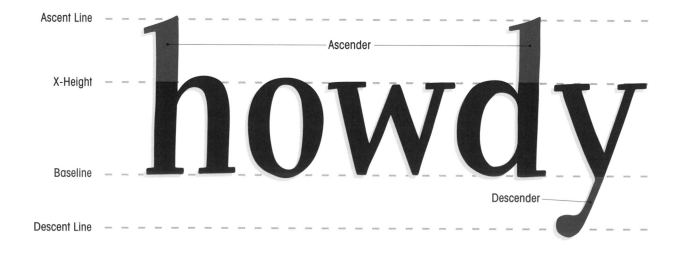

Ascent Line

Ascender

X-Height

Baseline

Descender

Descent Line

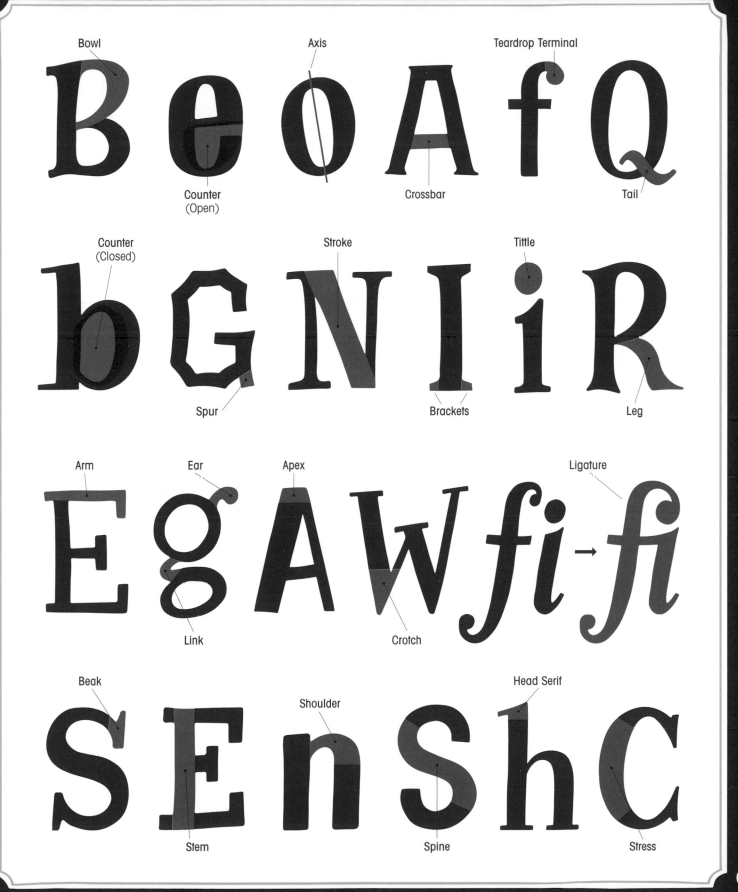

Bowl · Axis · Teardrop Terminal
Counter (Open) · Crossbar · Tail

Counter (Closed) · Stroke · Tittle
Spur · Brackets · Leg

Arm · Ear · Apex · Ligature
Link · Crotch

Beak · Shoulder · Head Serif
Stem · Spine · Stress

WEIGHT, WIDTH & CONTRAST

Weight, width, and contrast are the three main characteristics that distinguish lettering alphabets from one another. Making simple adjustments to these three traits can have a drastic effect on the look and overall feel of a letterform. Familiarize yourself with the differences below.

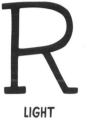 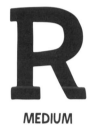 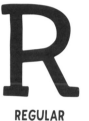 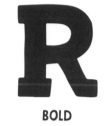

| LIGHT | REGULAR | MEDIUM | BOLD | BLACK |

1 WEIGHT Weight is the overall thickness of the strokes or lines that make up each letterform. Adjusting the weight of a letter can significantly affect its appearance.

| CONDENSED | REGULAR | EXTENDED |

2 WIDTH The width of a letterform refers to how wide or thin it appears to be in relation to its overall height. Three of the most common widths are shown above.

| NO CONTRAST | LIGHT CONTRAST | MEDIUM CONTRAST | HEAVY CONTRAST |

3 CONTRAST Contrast refers to the variation in stroke width throughout a given letterform. It is most noticeable where horiztontal and vertical strokes meet.

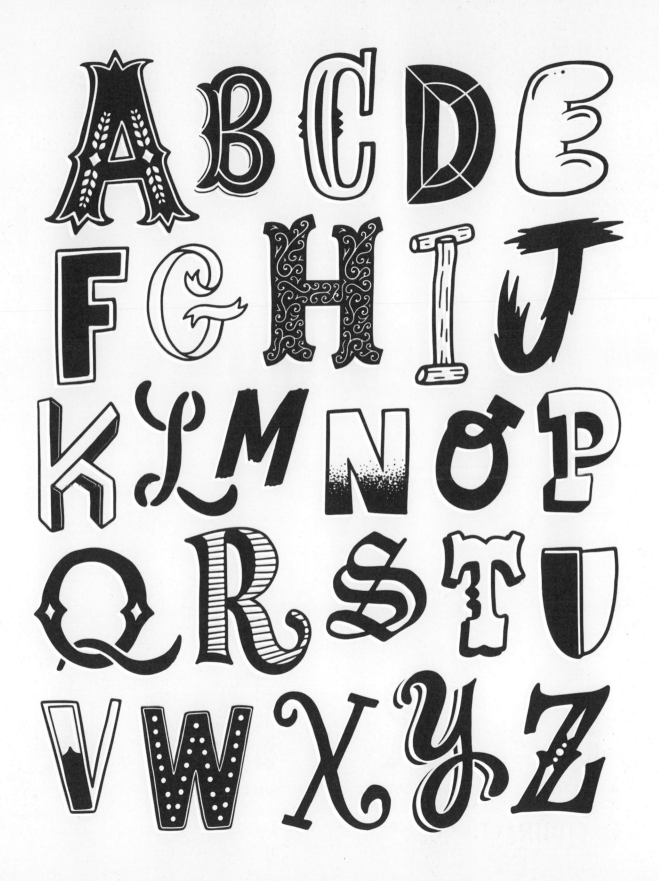

GETTING STARTED

TOOLS OF THE TRADE

Hand-lettering can be a bit intimidating when you're first starting out, especially when it comes to selecting the right tools for the job. Thankfully, you don't need to spend a ton of money on supplies to begin. Always keep in mind: It's not the tool that makes the art—it's the artist. Here are some essential and easy-to-find tools that I use to create hand-lettered artwork.

PENCILS

It's important to have a good set of pencils for initial sketching and planning. Whether mechanical or not, be sure to find a lead hardness that suits your style.

PENS

When it's time to ink your sketches, there is no better tool than a quality pen. Flat and round-tip are two good options to consider.

COLORED PENCILS & MARKERS

Colored pencils and markers are a nice option to use when it's time to color your artwork by hand. Both produce very different results. Markers provide vibrant, free-flowing, consistent color, whereas pencils create more of an organic look that shows more of the artist's strokes.

PAPER

A pad of tracing paper is always beneficial when planning your compositions. Use thicker paper with markers to prevent bleeding.

ERASERS

We all make mistakes, and although I prefer to use erasers sparingly, they are a great tool for minor revisions and tweaks.

DIGITAL TABLET & STYLUS

Many hand-lettering artists are transitioning to a digital tablet and stylus these days. The technology has become so advanced that it can be hard to distinguish work done by hand or tablet. There are many benefits to using a tablet and stylus, especially when it comes to efficiency throughout the lettering process.

THE LETTERING PROCESS

When I first started hand-lettering, the toughest thing to establish was a proper workflow process.
I had an idea of what I wanted my finished artwork to look like, but I didn't know how to get there.
Through lots of trial and error, I have come up with a simple process to create my lettering.

① WIREFRAME

Beginners have a tendency to skip important initial stages when creating lettering artwork, because it can be tempting to jump to the prettier final stages. In order to set yourself up for lettering success, start with a basic wireframe of a letterform. A wireframe provides an important backbone from which to work as you move through the stages of refining and finalizing your lettering. Don't worry about keeping lines straight or neat at this stage; you will not see the wireframe in the final product.

② ROUGH SKETCH

Once I have an adequate wireframe, I start to roughly sketch out a letterform. I don't worry about making sure my letterform is clean. My focus at this stage is to keep the lettering loose and free. The rough sketch stage is one of the most important phases of lettering, as it is where the lettering begins to take rough shape. Refrain from adding too much detail outside of the letterform's basic characteristics in this early stage.

③ REFINE SKETCH

Once the rough sketch composition is in a good place, I start to refine my lettering. I sketch directly over the letterform or use a sheet of tracing paper. This is the first stage where I begin to experiment with adding details, such as inner lining and dimensionality. This is typically the most time-consuming portion of the process, but it is rewarding to see the lettering take on a more finished look. Take your time during this step!

④ COLORIZATION

Now that I have a refined sketch, I move to the ink and colorization step. Use a marker or fine-tip black pen to trace your letterform. Don't rush and use a steady hand. Add any final details or finesse at this time. Once the ink has dried, use an eraser to remove the sketched lettering. If you're looking to refine your artwork even more, try scanning it into the computer at a high resolution (see page 18).

TAKE YOUR TIME THROUGHOUT THE PROCESS, AND EMBRACE THE IMPERFECTIONS IN YOUR LETTERING.

DIGITIZING YOUR LETTERING

Learning how to scan your artwork is necessary to bring your hand-lettering to the next level. I like to scan my ink drawings and further refine and colorize my lettering on the computer using digital design programs.

1 SCAN

Scan your final ink lettering into the computer at a high resolution to ensure maximum integrity. In most cases, 300 dpi or higher is adequate.

2 FINESSE

Once your artwork is scanned, open it up in an illustration or photo-editing program. Correct errors and clean up your work.

3 COLORIZE

Now that you have cleaned up your lettering, it's time to add some color. Play around with different color palettes until you are happy with the finished product.

SANS SERIF
ALPHABETS

JUNEBUG

STYLE: Sans serif **WEIGHT:** Regular **WIDTH:** Regular **CONTRAST:** None

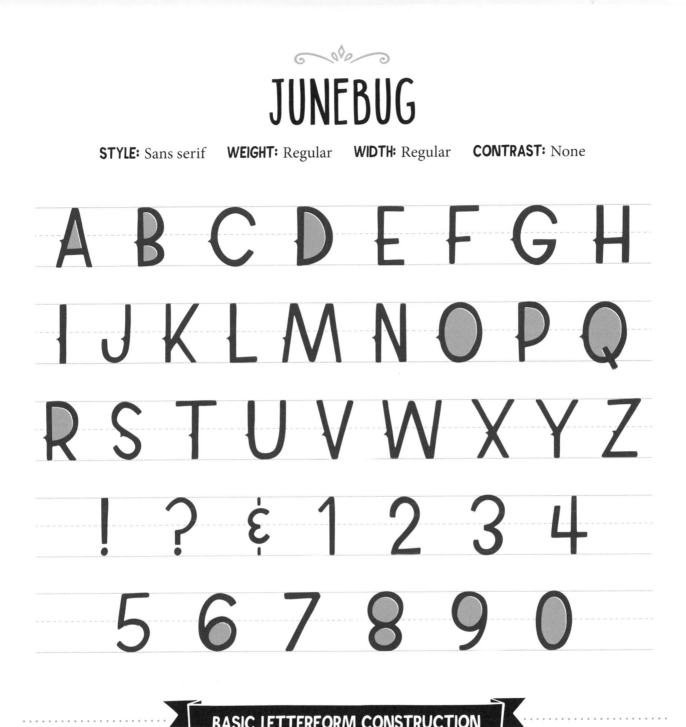

A B C D E F G H
I J K L M N O P Q
R S T U V W X Y Z
! ? & 1 2 3 4
5 6 7 8 9 0

BASIC LETTERFORM CONSTRUCTION

Begin with a basic wireframe. Keep it simple, as it will serve as a guide in future steps.

Visually break the letterform into a series of shapes, starting with the stem of the letter.

Add upper and lower strokes to complete the letterform. Finish with a small spur midway up the stem.

Trace over your sketch with purple ink. Fill the counters with a marigold color to complement the purple.

FRESHWAVE

STYLE: Sans serif **WEIGHT:** Bold **WIDTH:** Regular **CONTRAST:** Heavy

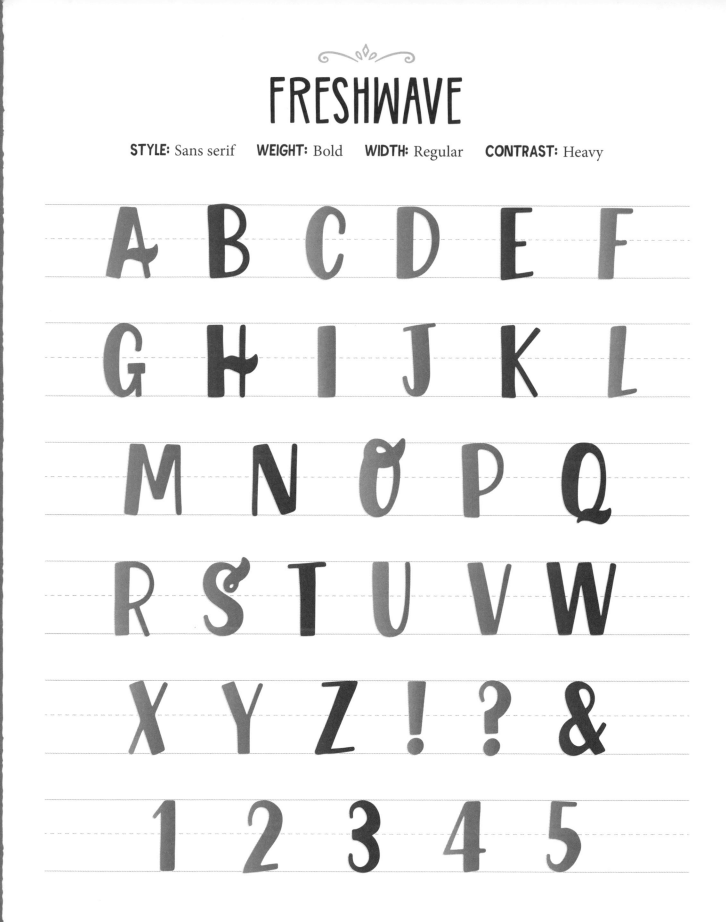

A B C D E F
G H I J K L
M N O P Q
R S T U V W
X Y Z ! ? &
1 2 3 4 5

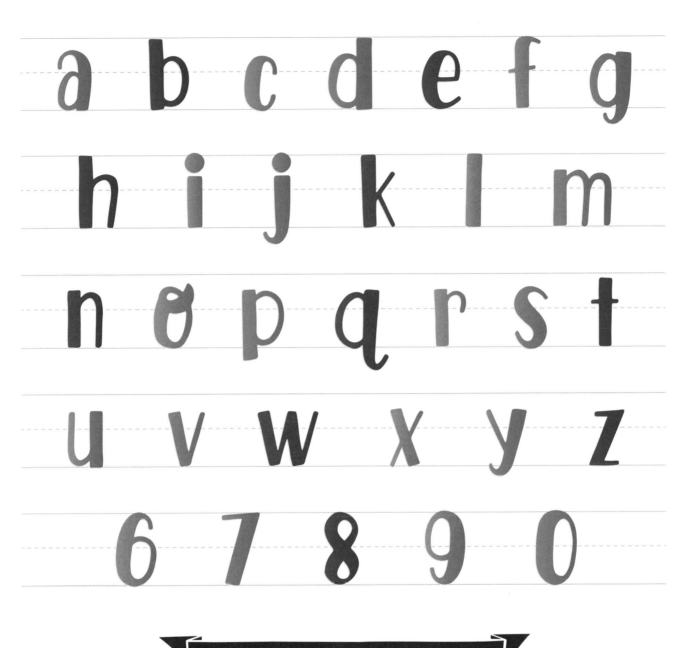

a b c d e f g
h i j k l m
n o p q r s t
u v w x y z
6 7 8 9 0

BASIC LETTERFORM CONSTRUCTION

Begin with a basic wireframe. Keep it simple, as it will serve as a guide in future steps.

Start to build out the thickness of the letterform. Use a mixture of thick and thin strokes to provide variation in contrast.

Add a swashy crossbar and make any last adjustments until you're happy with the refined sketch.

Trace over your sketch with orange ink. Take your time, and use a steady hand during this final step.

WANDERING ASTEROID

STYLE: Sans serif **WEIGHT:** Bold **WIDTH:** Regular **CONTRAST:** None

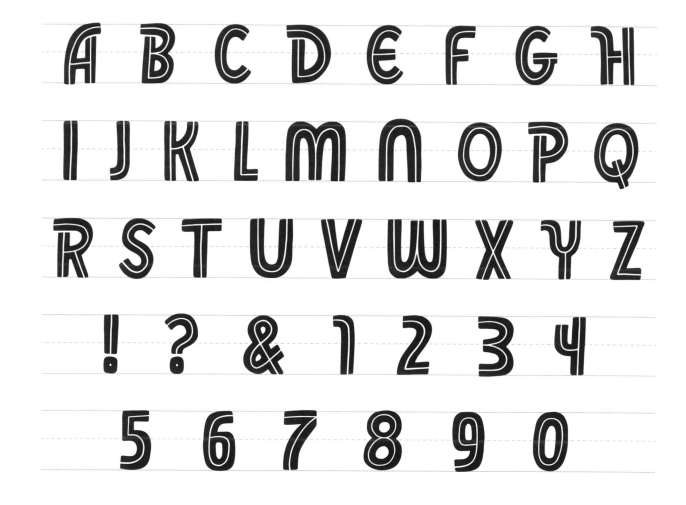

Lettering Alphabets & Artwork

BASIC LETTERFORM CONSTRUCTION

Begin with a basic wireframe. Keep it simple, as it will serve as a guide in future steps.

Visually break the letterform into a series of shapes, starting with the stem of the letter.

Add a curved upper shape with an open bowl, and add a leg. Make final adjustments until you're happy with the refined sketch.

Trace over your sketch with ink. Add a white inline that follows the contour of each stroke.

LETTERING COMPOSITION

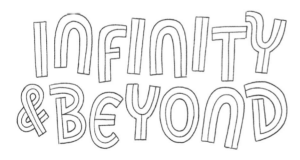

1 WIREFRAME

Start with a basic wireframe, and stack the words on two lines. Use a bounce lettering style, where each character is slightly angled. This will give the composition a floating appearance.

2 ROUGH SKETCH

Roughly sketch the thick letterforms over your wireframe. Break down each letterform into a series of shapes. Keep this lettering rough and loose, as it will serve as the foundation for future steps.

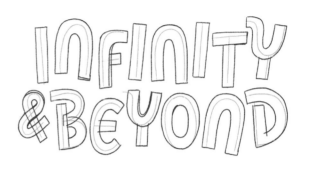

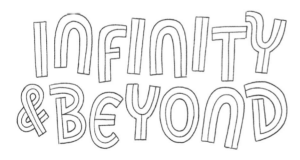

3 REFINE SKETCH

Once you're happy with the rough sketch composition, refine the lettering by tracing over it. Add an inline to each letterform. The finished product should have clean linework.

4 COLORIZATION

With a steady hand, trace over your sketch with black ink. Once you have the black ink down, introduce a simple three-color palette for the inner letter coloring. Use a black background to allow the composition to pop.

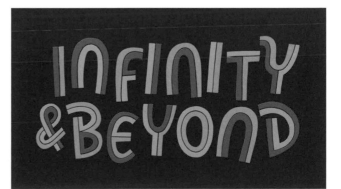

SMART DECO

STYLE: Sans serif **WEIGHT:** Regular **WIDTH:** Condensed **CONTRAST:** None

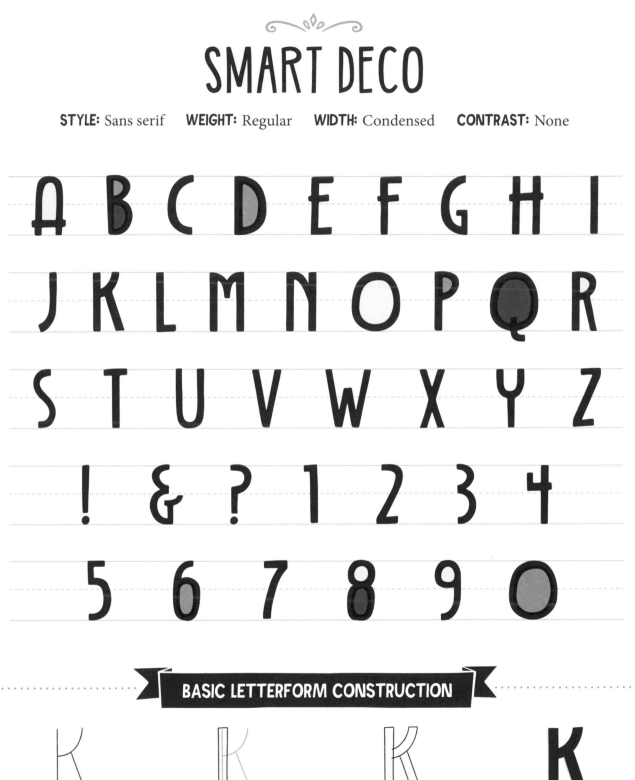

A B C D E F G H I
J K L M N O P Q R
S T U V W X Y Z
! & ? 1 2 3 4
5 6 7 8 9 0

BASIC LETTERFORM CONSTRUCTION

Begin with a basic wireframe. Keep it simple, as it will serve as a guide in future steps.

Visually break the letterform into a series of shapes, starting with the stem of the letter.

Add a curved diagonal upper stroke and a straight leg to complete the letterform.

Trace over your sketch with black ink. Take your time, and use a steady hand during this final step.

Lettering Alphabets & Artwork

LETTERING COMPOSITION

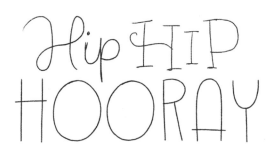

1 WIREFRAME

Start with a wireframe of the word "HOORAY," capturing the defining characteristics of this alphabet, such as the curved "A" and overlapping crossbars. Use smaller complementary lettering styles for the words above "HOORAY."

2 ROUGH SKETCH

Roughly sketch out the thick letterforms over the wireframe. Break down each letterform into a series of shapes. Draw the word "HOORAY" more thickly than the other words to create emphasis. Keep this lettering loose.

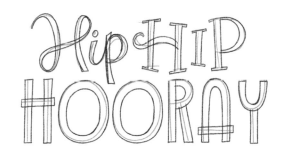

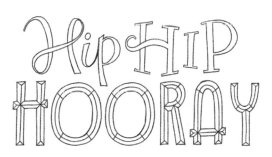

3 REFINE SKETCH

Once the rough sketch composition is in a good place, refine the lettering by tracing over it. Add inner dimensional detailing to the word "HOORAY." Once your linework is nice and clean, you are ready to move to the next step!

4 COLORIZATION

With a steady hand, trace over your sketch with black ink. Once you have the black ink down, introduce a simple palette of three to four colors. Fill in the counters of the words "Hip Hip" with different colors to make the composition more dynamic and interesting.

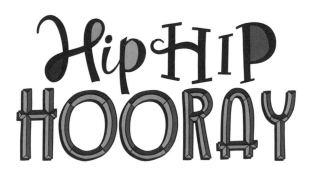

COOLIFORNIA

STYLE: Sans serif **WEIGHT:** Medium **WIDTH:** Condensed **CONTRAST:** None

A B C D E F G H
I J K L M N O P Q
R S T U V W X Y Z
! & ? 1 2 3 4
5 6 7 8 9 0

BASIC LETTERFORM CONSTRUCTION

Begin with a basic wireframe. Keep it simple, as it will serve as a guide in future steps.

Visually break the letterform into a series of shapes. Keep the stroke width relatively uniform.

Add the rest of the shapes to the letterform. Add some small spurs midway up the stem on both sides of the vertical strokes.

Trace over your sketch with ink. Take your time and use a steady hand during this final step.

Lettering Alphabets & Artwork

LETTERING COMPOSITION

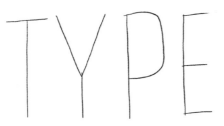

1 WIREFRAME

Start with a basic wireframe. Don't worry about keeping lines straight or pretty at this stage.

2 ROUGH SKETCH

Using the wireframe as a guide, roughly sketch out the letterforms. Add small spurs midway up each letter.

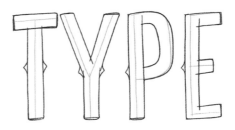

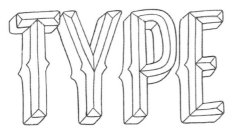

3 REFINE SKETCH

Once the rough sketch composition is in a good place, refine the lettering by tracing over it. Add inner dimensional detailing to each letter, along with an outer dimensional shadow.

4 COLORIZATION

To colorize your artwork, trace over your sketch with ink. Use black and gray ink for the drop shadow, along with some brighter colors for the inside of each letterform.

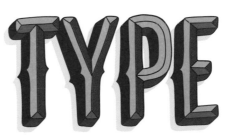

YOU FANCY

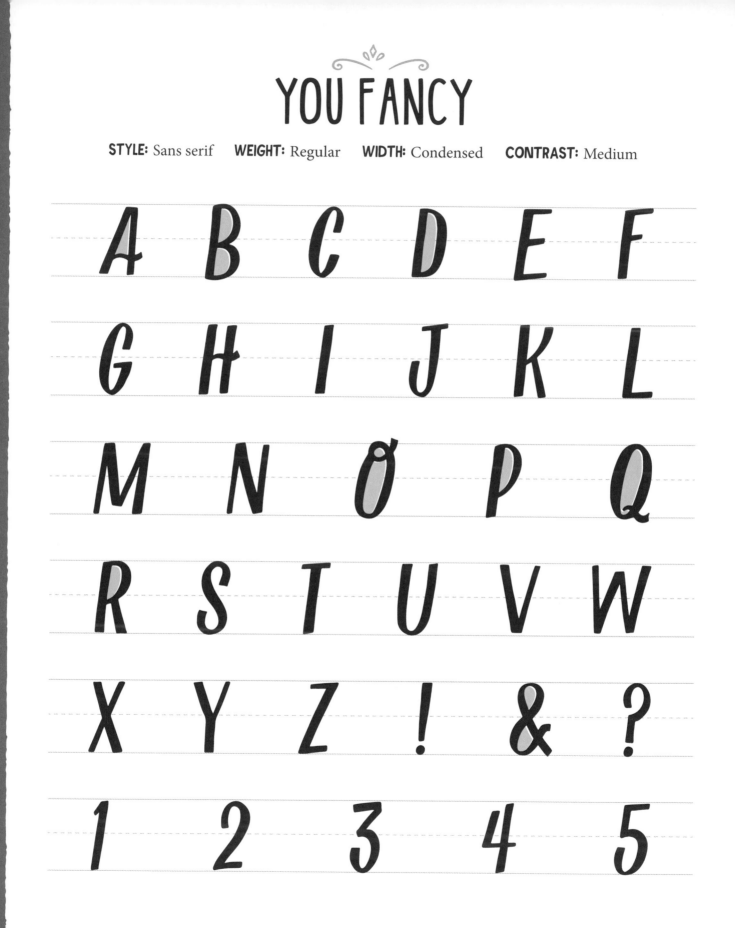

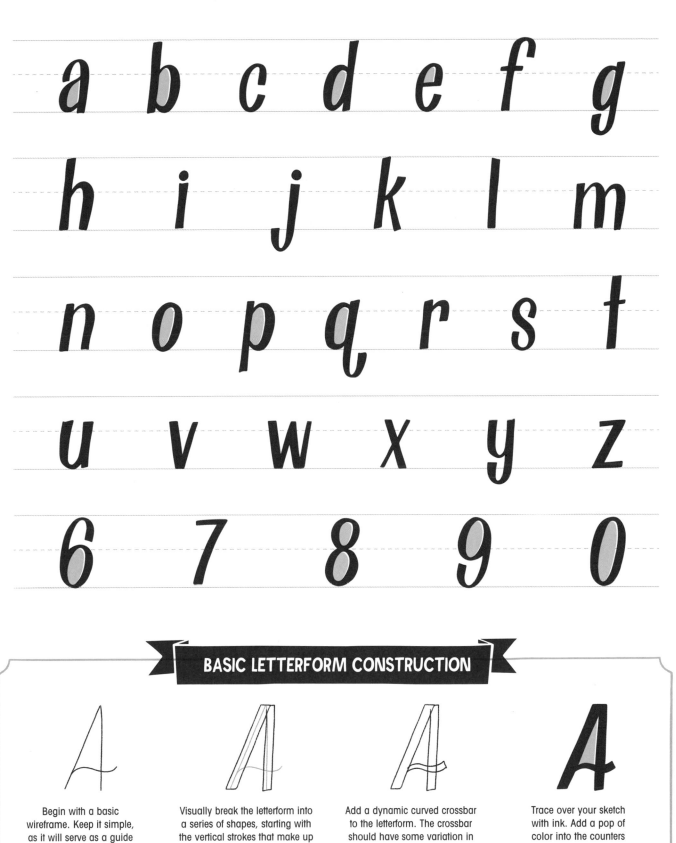

a b c d e f g

h i j k l m

n o p q r s t

u v w x y z

6 7 8 9 0

BASIC LETTERFORM CONSTRUCTION

Begin with a basic wireframe. Keep it simple, as it will serve as a guide in future steps.

Visually break the letterform into a series of shapes, starting with the vertical strokes that make up the letter.

Add a dynamic curved crossbar to the letterform. The crossbar should have some variation in the stroke, as seen above.

Trace over your sketch with ink. Add a pop of color into the counters of the letterform.

PINEAPPLE POWER

STYLE: Sans serif **WEIGHT:** Black **WIDTH:** Regular **CONTRAST:** Medium

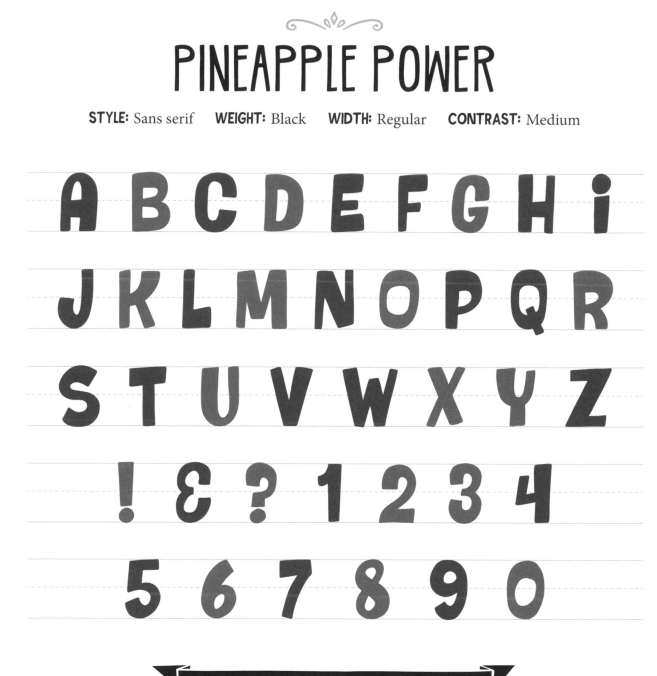

A B C D E F G H I
J K L M N O P Q R
S T U V W X Y Z
! & ? 1 2 3 4
5 6 7 8 9 0

BASIC LETTERFORM CONSTRUCTION

Begin with a basic wireframe. Keep it simple, as it will serve as a guide in future steps.

Visually break the letterform into a series of shapes, starting with the vertical strokes that make up the letter.

Add a slightly thicker, curved upper diagonal stroke and straight, thinner leg stroke to complete the letterform.

Trace over and color your sketch with dark green ink. Take your time and use a steady hand during this final step.

LETTERING COMPOSITION

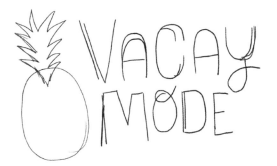

1 WIREFRAME

Start with a basic wireframe and a rough pineapple shape to serve as a guide. This lettering style is characterized by its imperfections, so keep this wireframe loose.

2 ROUGH SKETCH

Roughly sketch out each letterform. Allow your lettering to be imperfect and free. Focus on adding plenty of variation to the thickness of each stroke to bring contrast to the composition.

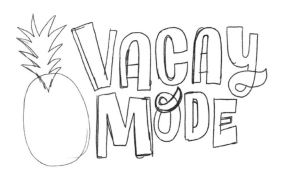

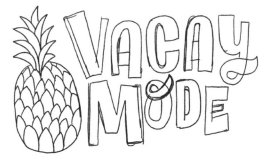

3 REFINE SKETCH

Once the rough sketch composition is in good shape, refine the pineapple illustration. Have fun with styling this artwork, as it is meant to have a playful feel.

4 COLORIZATION

To colorize your artwork, trace over your sketch with ink. Add additional details or color during this final step.

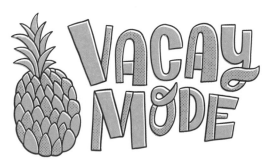

WINDOW SHOPPING

STYLE: Sans serif **WEIGHT:** Bold **WIDTH:** Regular **CONTRAST:** None

A B C D E F G H
I J K L M N O P Q
R S T U V W X Y Z

! ? & 1 2 3 4
5 6 7 8 9 0

BASIC LETTERFORM CONSTRUCTION

Begin with a basic wireframe. Keep it simple, as it will serve as a guide in future steps.

Visually break the letterform into a series of shapes, starting with the stem of the letterform.

Add a thin shadow outline and make any other adjustments until you're happy with the refined sketch.

Trace over your sketch with red ink. Use a tertiary color like gold for the shadow outline.

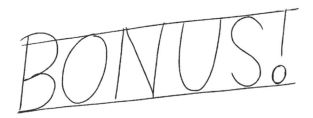

① WIREFRAME

Start with a basic wireframe. Don't worry about keeping lines straight or neat at this stage.

② ROUGH SKETCH

Roughly sketch out each letterform, keeping your lettering loose and free. Break down each letterform into a series of shapes, and focus on building out the thickness of each letter.

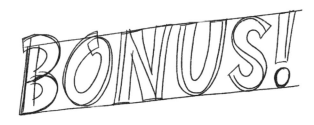

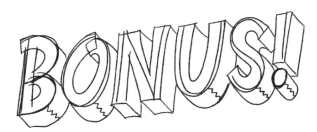

③ REFINE SKETCH

Once the rough sketch composition looks good, refine the lettering. Add a dimensional shadow to the composition to make it a bit more dynamic. Make sure your shadow linework follows the same angle as the letters—in this case, they are angled upwards from left to right.

④ COLORIZATION

To colorize your artwork, trace over your sketch with ink. Add additional details or color during this final step.

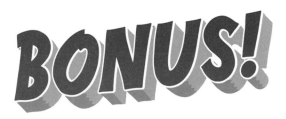

MOVIE NIGHT

STYLE: Sans serif **WEIGHT:** Bold **WIDTH:** Regular **CONTRAST:** Light

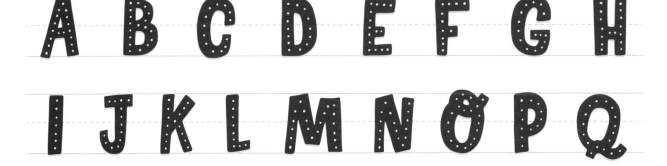

ABCDEFGH

IJKLMNOPQ

RSTUVWXYZ

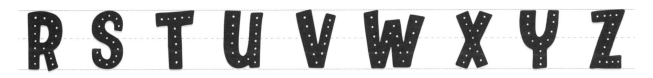

! ? & 1 2 3 4

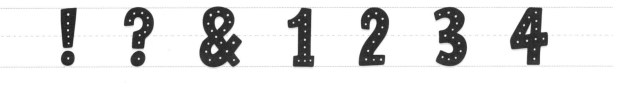

5 6 7 8 9 0

BASIC LETTERFORM CONSTRUCTION

Begin with a basic wireframe. Keep it simple, as it will serve as a guide in future steps.

Visually break the letter into a series of shapes. Pay close attention to the thickness of the letterform.

Add a dotted inline to the letter and make any other adjustments until you're happy with the refined sketch.

Trace over your sketch with ink. Take your time and use a steady hand during this final step.

1 WIREFRAME

Start with a basic wireframe. Draw two horizontal lines to use as guides for your lettering. Don't worry about keeping lines straight or pretty at this stage.

2 ROUGH SKETCH

Roughly sketch out each letterform, keeping your lettering loose and free. Focus on building out the thickness of each letter. Add a dimensional drop shadow, starting with the left character and moving right. Be sure to use the same angle for each letterform.

3 REFINE SKETCH

Once the rough sketch is in a good place, refine the lettering. Add a dotted inline inside the letters and some small popcorn illustrations to make the composition more dynamic.

4 COLORIZATION

To colorize your artwork, trace over your sketch with ink. Use a simple color palette of red and gold. Add additional details or color during this phase.

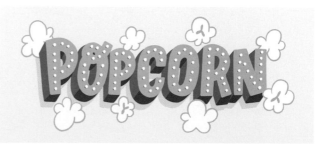

Sans Serif Alphabets

HOT DANG

STYLE: Sans serif **WEIGHT:** Bold **WIDTH:** Condensed **CONTRAST:** None

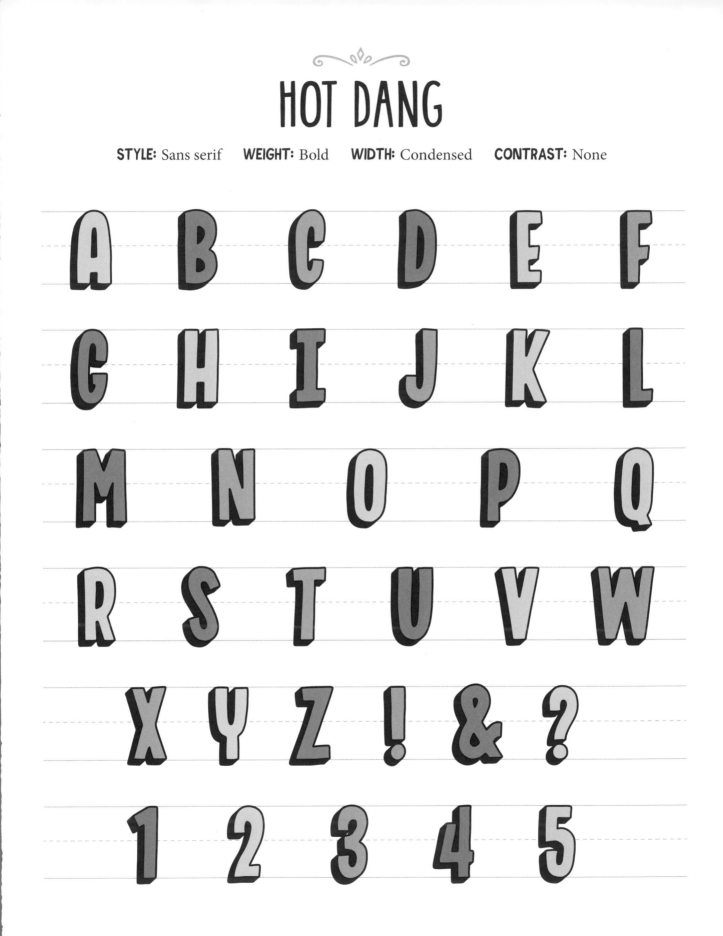

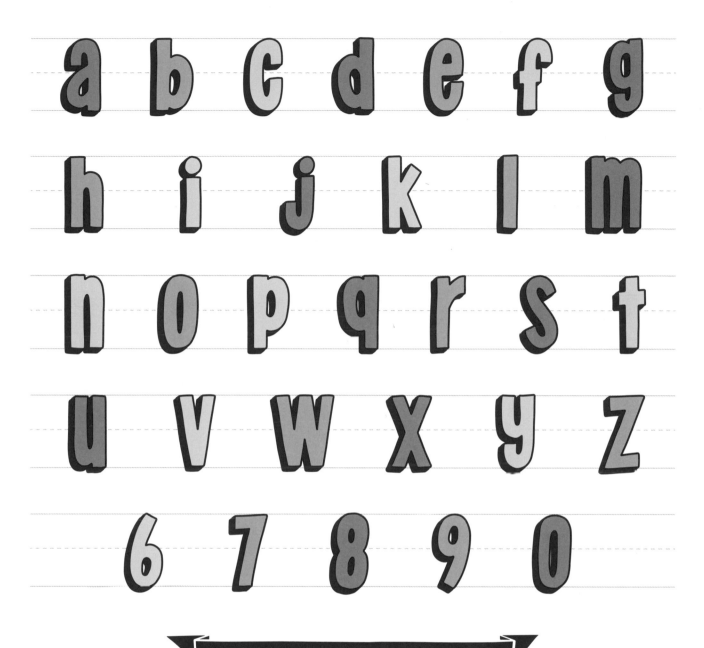

BASIC LETTERFORM CONSTRUCTION

Begin with a basic wireframe. Keep it simple, as it will serve as a guide in future steps.

Visually break the letterform into a series of shapes, starting with the vertical strokes that make up the letter.

Add a bold drop shadow to emphasize the letterform. Take your time planning out the diagonal shadowing.

Trace over your refined sketch with black ink. Add a bright pop of orange color inside the letterform.

SPLATTER DISCO

STYLE: Sans serif **WEIGHT:** Black **WIDTH:** Regular **CONTRAST:** Heavy

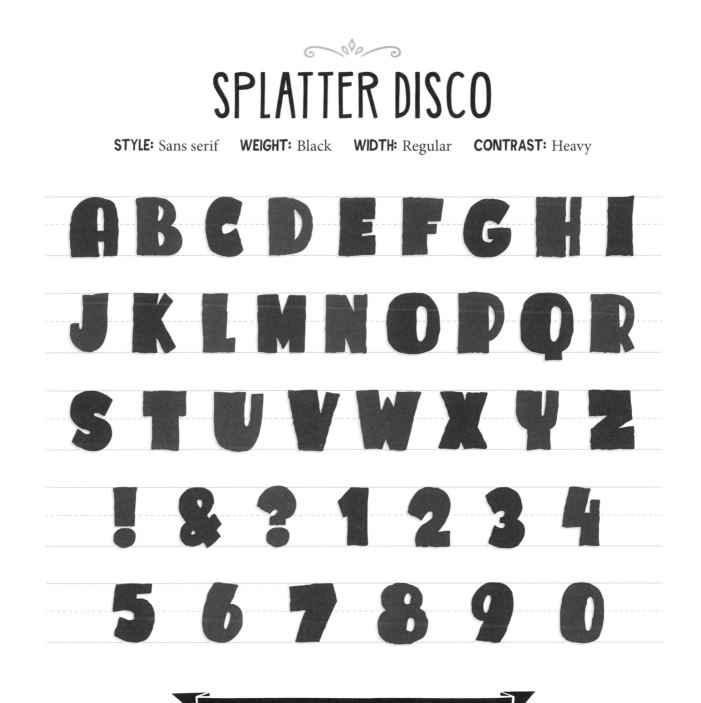

ABCDEFGHI
JKLMNOPQR
STUVWXYZ
! & ? 1 2 3 4
5 6 7 8 9 0

BASIC LETTERFORM CONSTRUCTION

Begin with a basic wireframe. Keep it simple, as it will serve as a guide in future steps.

Visually break the letterform into a series of shapes. Keep each shape nice and chunky.

Refine the shape with fun shaky-styled linework to give it more character.

Trace over and color your sketch with purple ink. Take your time and use a steady hand during this final step.

LETTERING COMPOSITION

1 WIREFRAME

Start with a basic wireframe. Emphasize important keywords and deemphasize less important words to create a more dynamic composition. Don't worry about keeping lines straight at this stage.

2 ROUGH SKETCH

Break down each letterform into a series of shapes and focus on building the chunkiness of each letter. As seen with the alphabet on the page 40, use a mixture of thick and thin strokes to create contrast and add interest.

3 REFINE SKETCH

Once the rough sketch composition is complete, refine the lettering. Break the letterforms into pieces to create a stencil aesthetic. Use a shaky line style to add visual interest to the lettering.

4 COLORIZATION

To colorize your artwork, trace over your sketch with ink. Use red, magenta, and black for a color scheme.

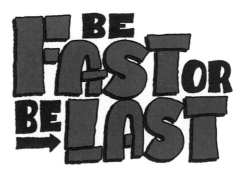

ANALOG DIGITAL

STYLE: Sans serif **WEIGHT:** Regular **WIDTH:** Regular **CONTRAST:** None

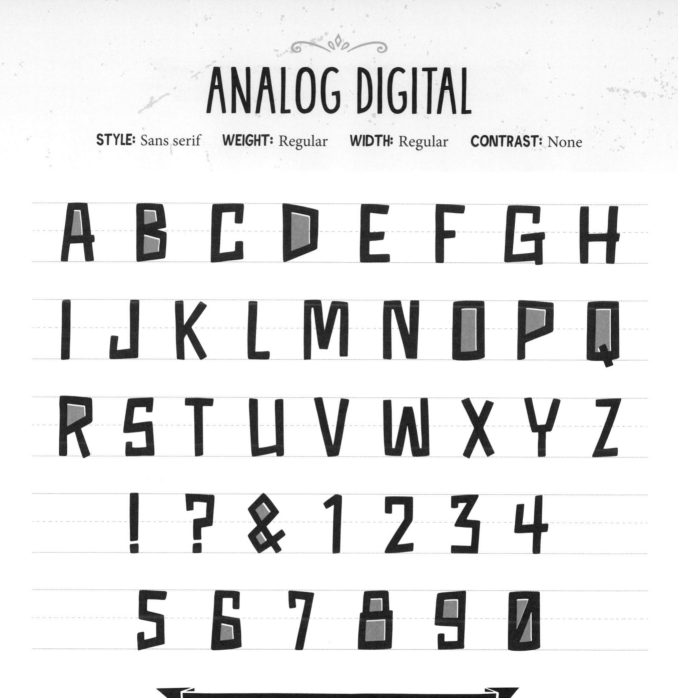

ABCDEFGH
IJKLMNOPQ
RSTUVWXYZ
!?&1234
567890

Begin with a basic wireframe. Keep it simple, as it will serve as a guide in future steps.

Visually break the letterform into a series of angular shapes, starting with the vertical strokes.

Add horizontal strokes to the letterform; make sure each stroke has the same thickness.

Trace over your sketch with dark blue ink. Take your time and use a steady hand during this final step.

LETTERING COMPOSITION

1 WIREFRAME

Start with a basic wireframe. Emphasize important keywords and deemphasize less important words to create a more dynamic composition. Don't worry about keeping lines straight at this stage.

2 ROUGH SKETCH

Break down each letterform into a series of shapes. Keep each letterform angular to preserve the defining characteristic of this alphabet. Use a slightly thinner stroke with the smaller words in this composition.

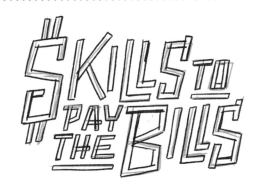

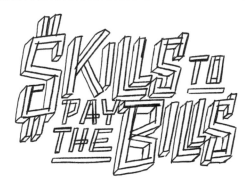

3 REFINE SKETCH

Once the rough sketch composition is complete, refine the lettering. Add a dimensional drop shadow to emphasize the most important words. From left to right, draw angular linework to create more dimension.

4 COLORIZATION

To colorize your artwork, trace over your sketch with ink. Add additional details or color during this phase.

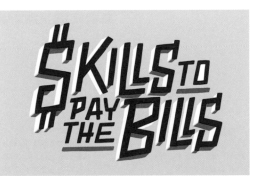

TIGER LILY

STYLE: Sans serif **WEIGHT:** Light **WIDTH:** Condensed **CONTRAST:** None

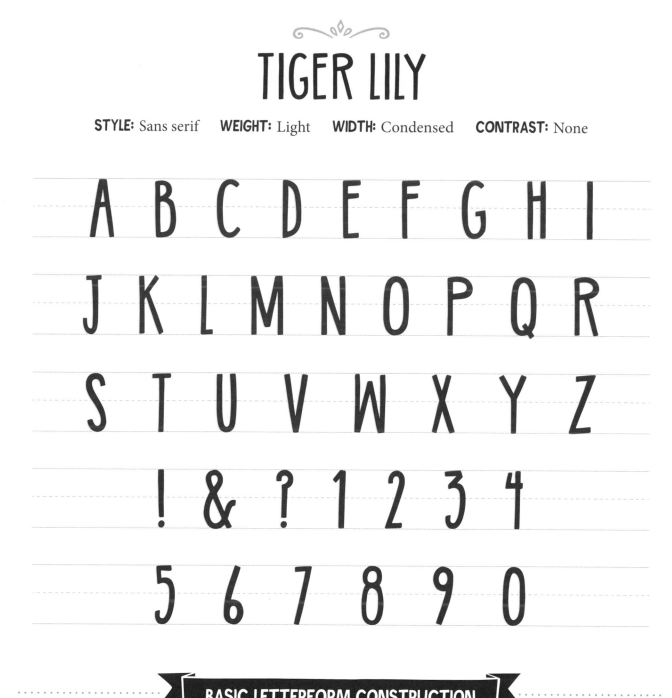

A B C D E F G H I
J K L M N O P Q R
S T U V W X Y Z
! & ? 1 2 3 4
5 6 7 8 9 0

BASIC LETTERFORM CONSTRUCTION

Begin with a basic wireframe. Keep it simple, as it will serve as a guide in future steps.

Visually break the letterform into a series of shapes, starting with the stem of the letter.

Add a diagonal upper stroke and a lower leg stroke. Keep the thickness of each stroke the same.

Trace over your sketch with dark blue ink. Take your time and use a steady hand during this final step.

LETTERING COMPOSITION

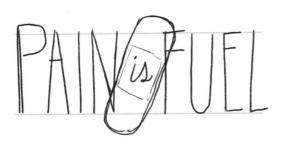

1 WIREFRAME

Start with a basic wireframe. Add a bandage sketch to contain the word "is" in cursive. Adding complementary lettering styles and simple illustrations can make your lettering composition more dynamic.

2 ROUGH SKETCH

Break down each letterform into a series of shapes. This alphabet style uses a more uniform stroke thickness. Don't worry about overlapping the bandage illustration, as this will add some visual interest to your composition.

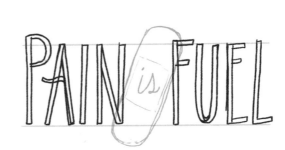

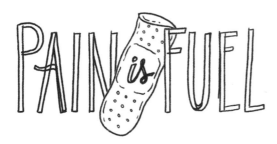

3 REFINE SKETCH

Once the rough sketch composition is complete, refine the lettering and illustration. Take your time working through each letterform, and have fun with the bandage illustration. Adding fun details will bring it to life!

4 COLORIZATION

To colorize your artwork, trace over your sketch with ink. Add in more details and texture during this phase.

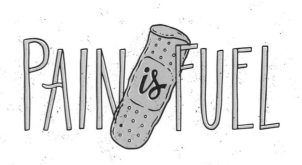

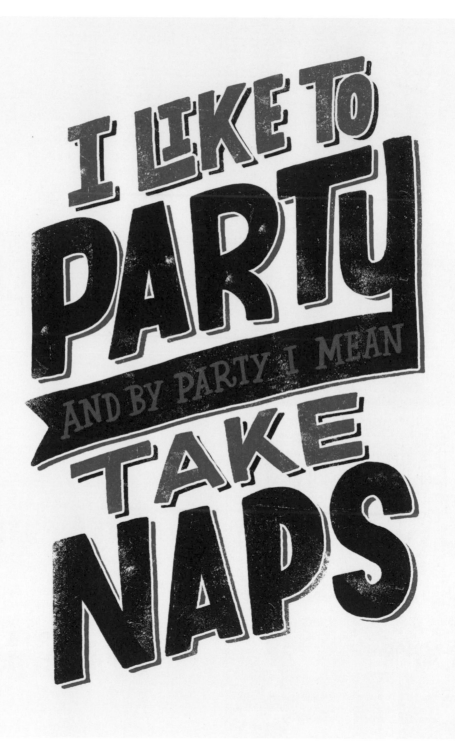

▲ Above
Naps
By Jay Roeder

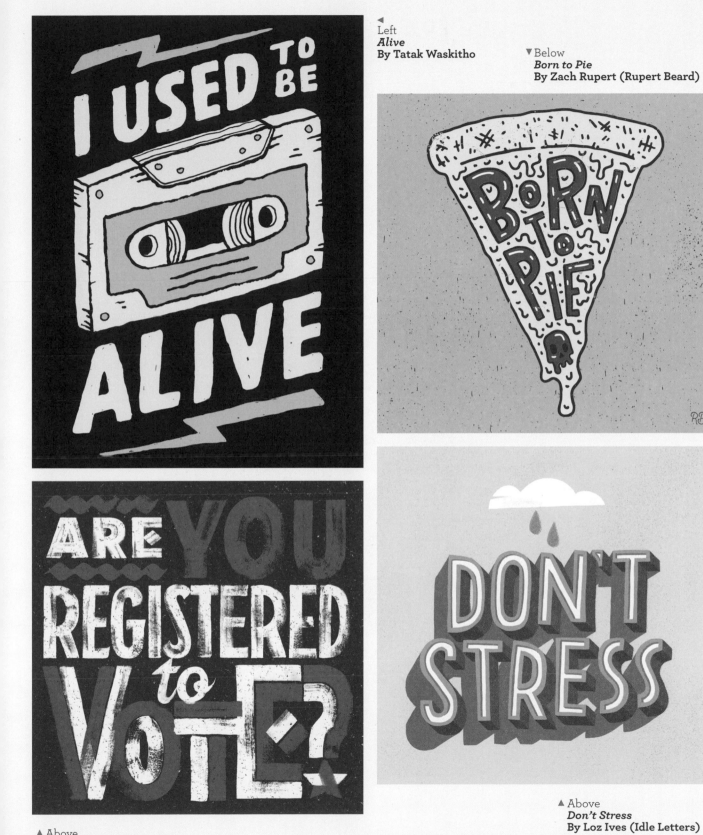

◄ Left
Alive
By Tatak Waskitho

▼ Below
Born to Pie
By Zach Rupert (Rupert Beard)

▲ Above
Are You Registered to Vote?
By Kyle Letendre

▲ Above
Don't Stress
By Loz Ives (Idle Letters)

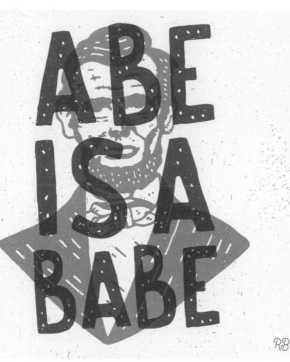

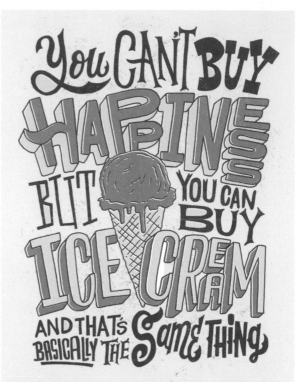

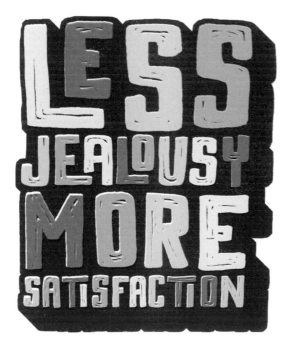

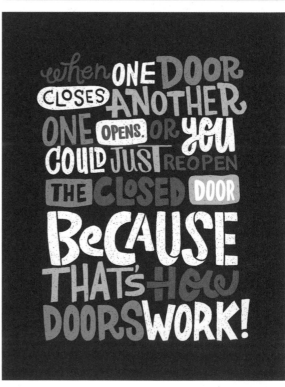

▲ Above
Less Jealousy More Satisfaction
By João Neves
Client: Vodafone
Agency: J. Walter Thompson

▲ Above
That's How Doors Work
By Matthew Taylor Wilson

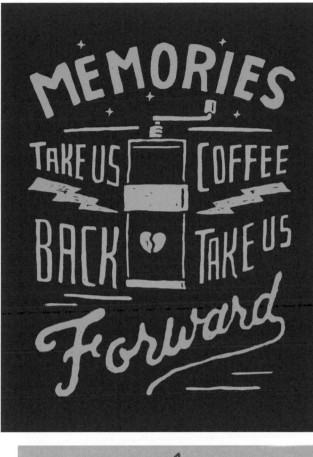

◄ Left
Memories
By Tatak Waskitho

▼ Below
Meh
By Ian Barnard

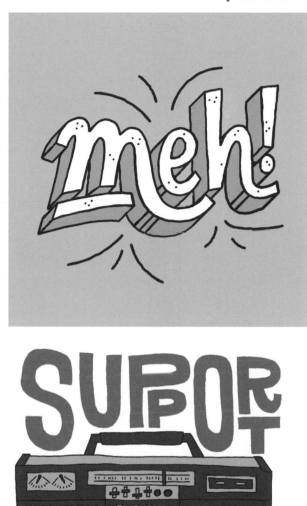

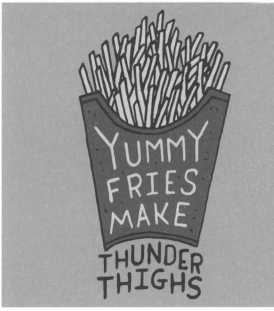

▲ Above
Thunder Thighs
By Zach Rupert (Rupert Beard)

▲ Above
Boombox Classics
By Jay Roeder

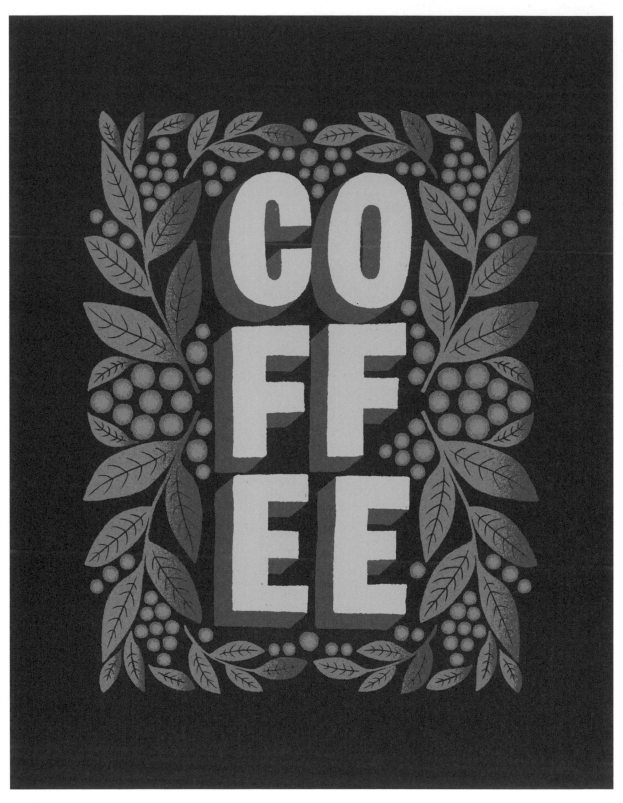

▲ Above
Coffee
By Matthew Taylor Wilson

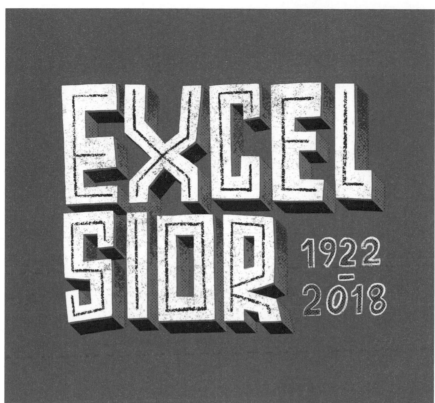

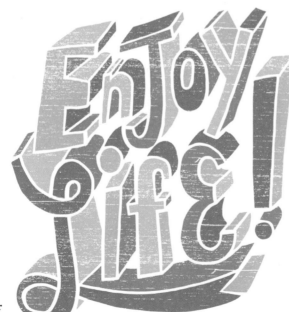

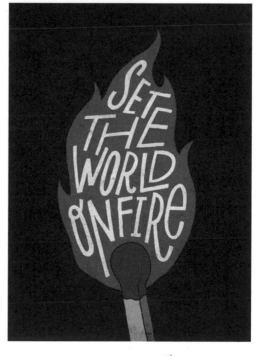

Sans Serif Alphabets

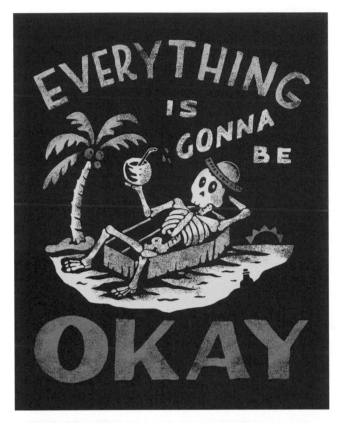

◀
Left
Okay
By Tatak Waskitho

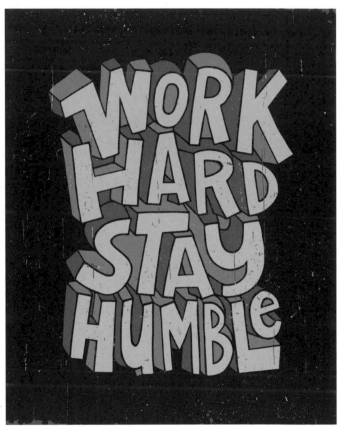

▲ Above
Work Hard Stay Humble
By Jay Roeder

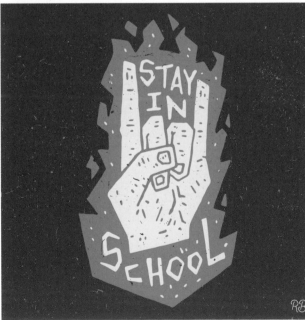

◀
Left
Stay in School
By Zach Rupert (Rupert Beard)

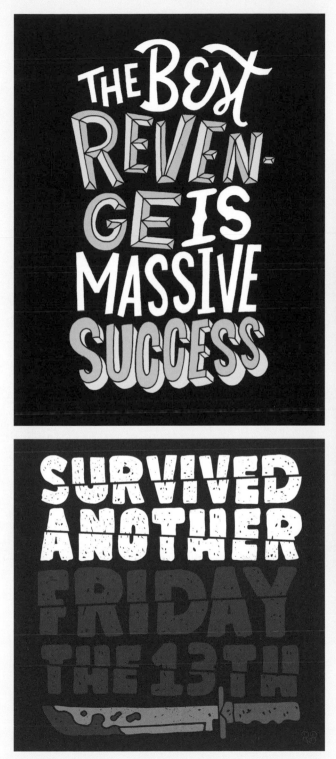

THE BEST REVENGE IS MASSIVE SUCCESS

SURVIVED ANOTHER FRIDAY THE 13TH

▲ Above
Friday the 13th
By Zach Rupert (Rupert Beard)

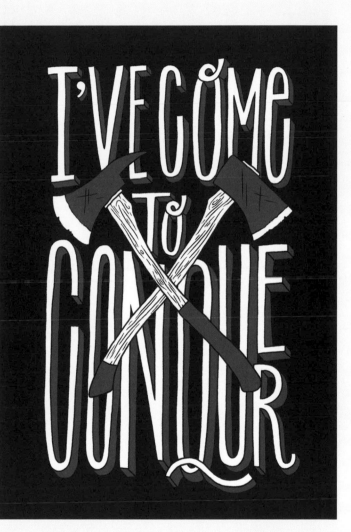

I'VE COME TO CONQUER

▲ Above
Conquer
By Jay Roeder

Sans Serif Alphabets

53

SERIF
ALPHABETS

CHEERTOWN

STYLE: Serif **WEIGHT:** Regular **WIDTH:** Condensed **CONTRAST:** None

ABCDEFGHI
JKLMNOPQR
STUVWXYZ
! & ? 1 2 3 4
5 6 7 8 9 0

BASIC LETTERFORM CONSTRUCTION

Begin with a basic wireframe. Keep it simple, as it will serve as a guide in future steps.

Visually break the letterform into a series of shapes. Keep the stroke width relatively uniform.

Add slab serifs to the end of each stroke. The serifs should maintain the same thickness as each existing stroke.

Trace over your sketch with dark blue ink. Take your time and use a steady hand during this final step.

FREAKING OUT

STYLE: Serif **WEIGHT:** Regular **WIDTH:** Condensed **CONTRAST:** Light

A B C D E F G H
I J K L M N O P Q
R S T U V W X Y Z
! ? & 1 2 3 4
5 6 7 8 9 0

BASIC LETTERFORM CONSTRUCTION

Begin with a basic wireframe. Keep it simple, as it will serve as a guide in future steps.

Visually break the letterform into a series of shapes, starting with the stem of the letter.

Add sharp angular serifs to the top and bottom of the stem and to the end of the leg stroke.

Trace over your sketch with dark red ink. Create a gradient by shading with dark red at the bottom of the letterform.

Lettering Alphabets & Artwork

LETTERING COMPOSITION

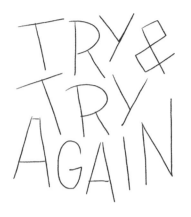

① WIREFRAME

Start with a basic wireframe. Stack the words on top of one another, fitting each character into the composition like a puzzle piece to create a tight lettering lockup.

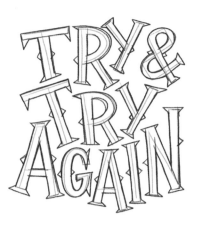

② ROUGH SKETCH

Roughly build out the thickness of each letterform over your wireframe. Add sharp serifs to the ends of each stroke. Build on this style by adding small angular spurs midway up each letter stem as well.

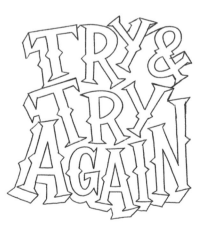

③ REFINE SKETCH

Once the rough sketch composition is in a good place, refine the letterforms by tracing over the sketch. Add a dimensional drop shadow to the entire composition.

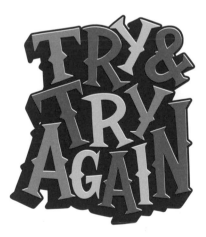

④ COLORIZATION

To colorize your artwork, trace over your sketch with ink. Trace over the linework with black ink. When it's time to add color, use a variety of oranges to color each letterform.

PUNCH POP

STYLE: Serif **WEIGHT:** Bold **WIDTH:** Regular **CONTRAST:** Heavy

Lettering Alphabets & Artwork

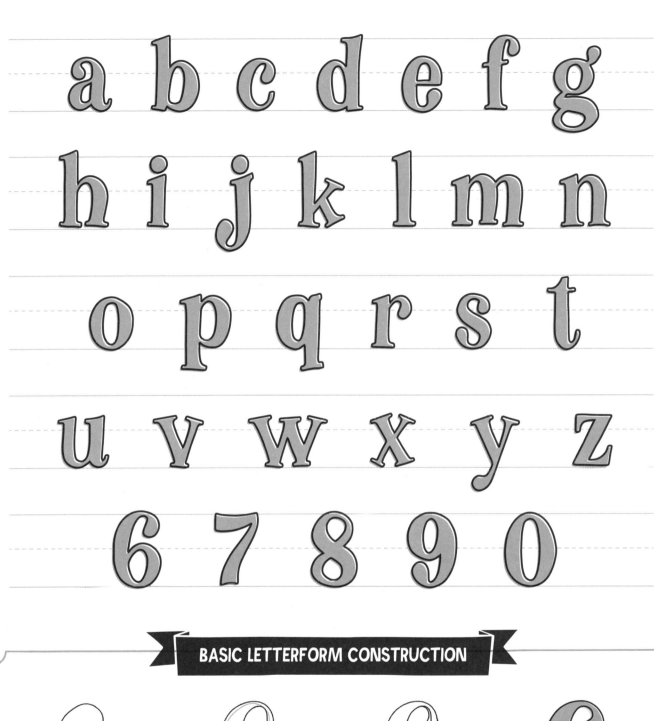

a b c d e f g
h i j k l m n
o p q r s t
u v w x y z
6 7 8 9 0

BASIC LETTERFORM CONSTRUCTION

Begin with a basic wireframe. Keep it simple, as it will serve as a guide in future steps.

Start to build out the thickness of the letterform. Use a mixture of thick and thin stroke widths to provide strong variation in contrast.

Add a rounded finial to the top of the letterform. Round the joints of the corners to create bracketed serifs.

Trace over your sketch with black. Add a pop of teal to the inner letterform.

Serif Alphabets

59

NEW ANTIQUE

STYLE: Serif **WEIGHT:** Bold **WIDTH:** Extended **CONTRAST:** Light

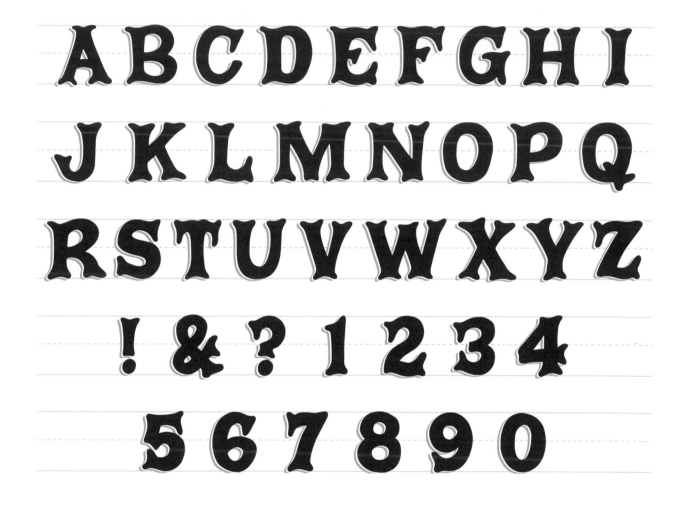

A B C D E F G H I
J K L M N O P Q
R S T U V W X Y Z
! & ? 1 2 3 4
5 6 7 8 9 0

BASIC LETTERFORM CONSTRUCTION

Begin with a basic wireframe. Keep it simple, as it will serve as a guide in future steps.

Visually break the letterform into a series of shapes, starting with the stem of the letter.

Add serif shapes to the ends of each stroke. Draw each serif with a rounded shape, as shown above.

Trace over your sketch with dark ink. Add a golden drop shadow to the left of each stroke.

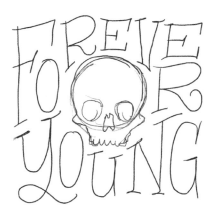

① WIREFRAME

Draw a skull shape in the middle of your layout. Draw wireframe lettering in a square formation around the skull. The lettering should work around the skull shape and fill the square. Stack letters to shake things up.

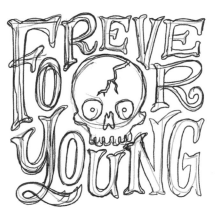

② ROUGH SKETCH

Roughly build out the thickness of each letterform, using the wireframe as a guide. This step should bring the letter styling to life. Focus on the rounded style of each serif. Add more detail to the cracked skull. Keep the sketch very loose.

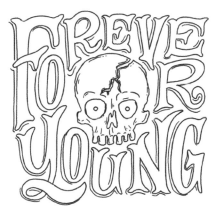

③ REFINE SKETCH

Once the rough sketch composition is in a good place, trace over it to refine the lettering and skull. Add a thin drop shadow to the lettering along with cracks and details to the skull.

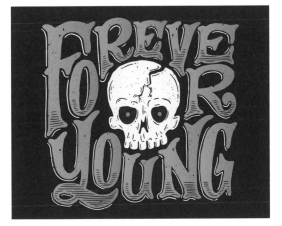

④ COLORIZATION

To colorize your artwork, trace over your sketch with ink. Use a simple vintage-inspired color palette of gold and off-white. Feel free to add more details during this phase, such as inner letter detailing or gritty texture.

PIXIE FREAK

STYLE: Serif **WEIGHT:** Medium **WIDTH:** Regular **CONTRAST:** Medium

A B C D E F G H I
J K L M N O P Q R
S T U V W X Y Z

! ? & 1 2 3 4
5 6 7 8 9 0

BASIC LETTERFORM CONSTRUCTION

Begin with a basic wireframe. Keep it simple, as it will serve as a guide in future steps.

Break the letterform into a series of shapes, starting with the stem and finishing with the curved bowl shapes.

Add bracketed serifs to the bottom of the stem and a flourished serif with a rounded finial-shaped end at the top.

Trace over your sketch with dark blue ink. Take your time, and use a steady hand during this final step.

Lettering Alphabets & Artwork

1 WIREFRAME

Begin with a simple wireframe. Draw the first letter slighly taller than the rest of the letters. Don't worry about making everything perfect.

2 ROUGH SKETCH

Roughly build out the thickness of each letterform. Establish the defining characteristics of the alphabet, such as the swashy crossbar of the letter "A" and the bracketed serifs at the end of each stroke.

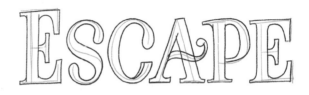

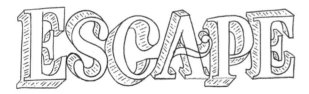

3 REFINE SKETCH

Once the rough sketch composition is in a good place, refine the lettering by tracing over it. Add a dimensional drop shadow using a different angle for each character. Add small line details to the inside of the drop shadow.

4 COLORIZATION

To colorize your artwork, trace over your sketch with ink. Use a simple color palette of red and orange. The finished product should give the impression that each character is floating and angled in different directions.

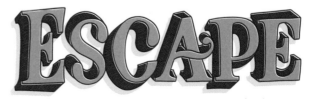

COWBOY CLOWNS

STYLE: Serif **WEIGHT:** Medium **WIDTH:** Regular **CONTRAST:** Medium

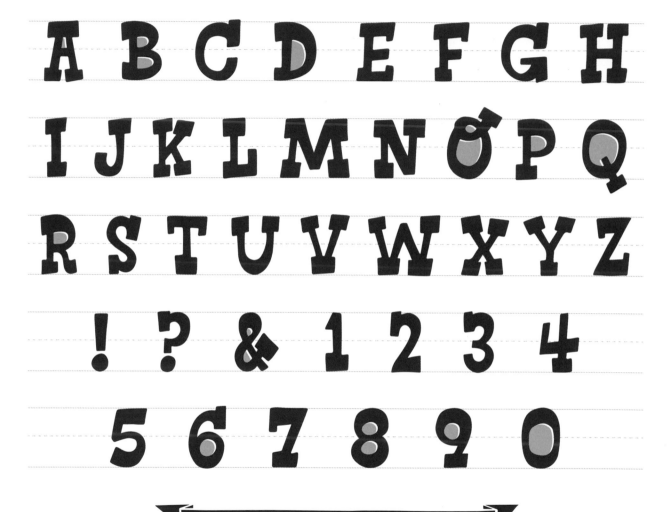

A B C D E F G H
I J K L M N O P Q
R S T U V W X Y Z

! ? & 1 2 3 4

5 6 7 8 9 0

BASIC LETTERFORM CONSTRUCTION

Begin with a basic wireframe. Keep it simple, as it will serve as a guide in future steps.

Visually break the letterform into a series of shapes, starting with the vertical strokes of the letter.

Add chunky misaligned slab serifs to the apex of the letter and to the bottom ends of each stroke.

Trace over your sketch with dark ink. Fill in the closed counter with a pop of orange.

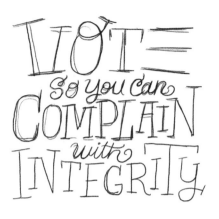

① WIREFRAME

Begin by stacking wireframe words on top of one another, allowing each character to fit into the composition like a puzzle piece. Use a mixture of large and small words to establish emphasis. Add a second style like cursive to complement the chunky slab serif lettering.

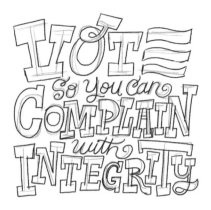

② ROUGH SKETCH

Roughly build out the thickness of each letterform. Establish the defining characteristics of the featured slab serif alphabet, such as the misaligned serifs and high-contrast stroke variation. Convert the letter "E" into wavy flag stripes to emphasize the patriotic theme.

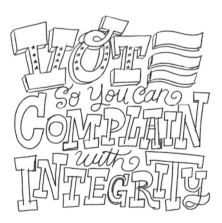

③ REFINE SKETCH

Once the rough sketch composition is in a good place, refine the lettering by tracing over it. Emphasize the word "VOTE" by adding a dimensional shadow and some inner lettering star details.

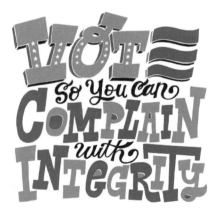

④ COLORIZATION

Fill in your lettering with ink. Introduce a color palette of red, white, and blue. Color smaller cursive lettering with a darker color, such as black, to ensure legibility.

ROTTEN ALCHEMIST

STYLE: Serif **WEIGHT:** Bold **WIDTH:** Condensed **CONTRAST:** Medium

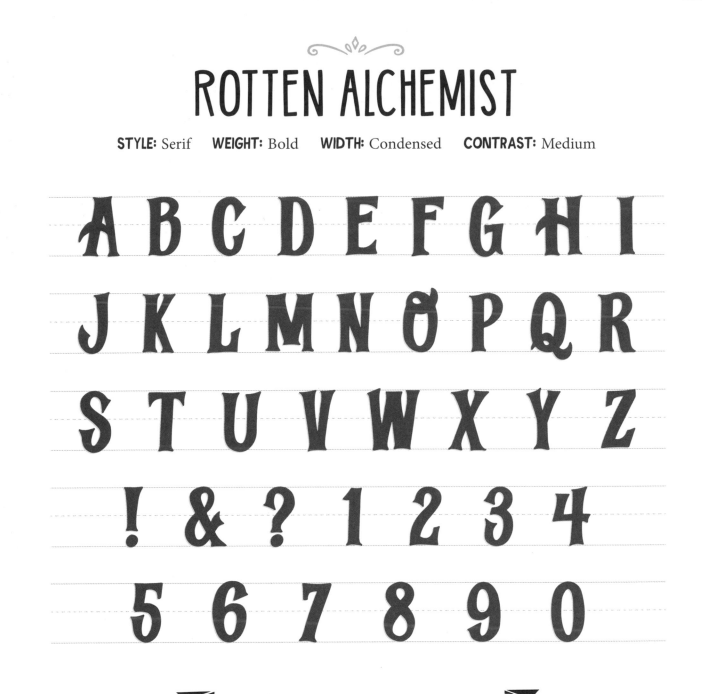

A B C D E F G H I
J K L M N O P Q R
S T U V W X Y Z
! & ? 1 2 3 4
5 6 7 8 9 0

BASIC LETTERFORM CONSTRUCTION

Begin with a basic wireframe. Capture the curves and shapes shown in the alphabet above.

Visually break the letterform into a series of shapes, starting with the stem of the letter.

Add flared, sharp serifs to the top and bottom of the stem and to the end of the leg stroke.

Trace over your sketch with dark green ink. Add a faint lime-green drop shadow to the left of each stroke.

LETTERING COMPOSITION

① WIREFRAME

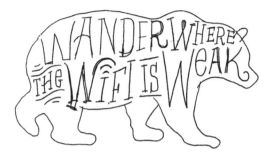

Start by drawing a silhouette of a bear. Fill the inside of the shape with lettering. Use larger lettering to emphasize more important words and smaller lettering for less important words.

② ROUGH SKETCH

Roughly sketch out each letterform. Use the wireframe as a guide. Keep the lettering simple, and focus on giving yourself a good foundation to work from as you progress to the next step.

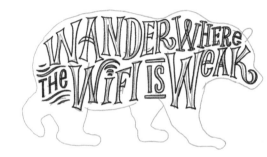

③ REFINE SKETCH

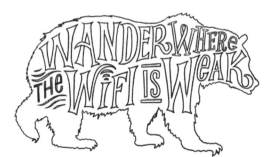

Once the rough sketch composition is in a good place, refine the lettering by tracing over it and cleaning up the linework. Add more details to the bear silhouette to help bring it to life.

④ COLORIZATION

To colorize your artwork, trace over your sketch with ink. Use a simple color palette or two to three colors. Use a bright color like marigold to emphasize important words.

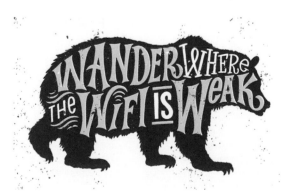

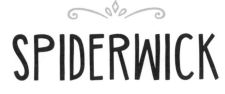

SPIDERWICK

STYLE: Serif **WEIGHT:** Regular **WIDTH:** Regular **CONTRAST:** Low

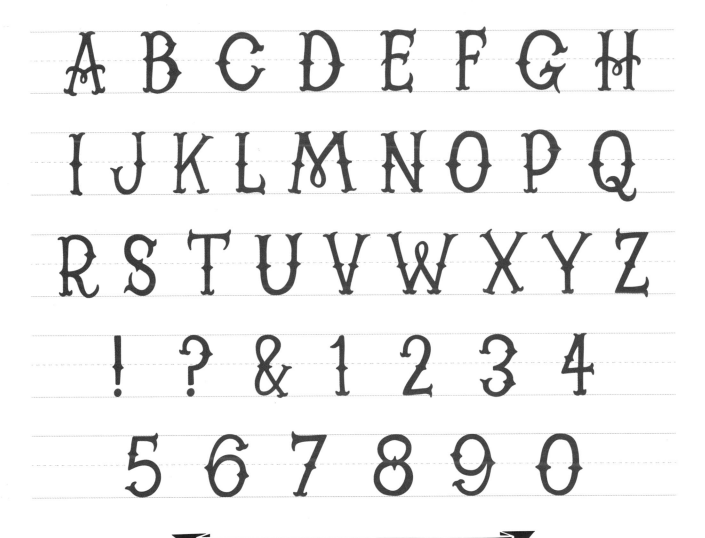

A B C D E F G H
I J K L M N O P Q
R S T U V W X Y Z
! ? & 1 2 3 4
5 6 7 8 9 0

BASIC LETTERFORM CONSTRUCTION

Begin with a basic wireframe. Capture the curves and shapes shown in the alphabet above.

Break the letterform into a series of shapes. Start with the vertical strokes and a curled crossbar.

Add sharp ornamental serifs to the apex and bottoms of each stroke. Refine the crossbar.

Trace over your sketch with purple ink. Take your time, and use a steady hand during this final step.

LETTERING COMPOSITION

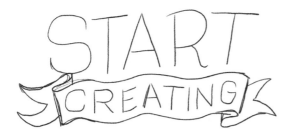

1 WIREFRAME

Start by drawing a wavy banner. Add lettering above and within the banner. Be sure to follow the contours of the inner banner shape. Keep the lettering loose and simple.

2 ROUGH SKETCH

Roughly sketch out each letterform. Keep the lettering simple, and focus on giving yourself a good foundation to work from as your progress to the next step.

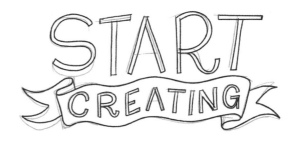

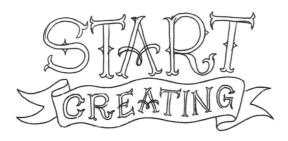

3 REFINE SKETCH

Once the rough sketch composition is in a good place, refine the lettering by tracing over it. Add ornamental serifs to the end of each stroke, and small spurs midway up the letterforms. Add curled crossbar flourishes. Refine the banner by cleaning up the linework.

4 COLORIZATION

To colorize your artwork, trace over your sketch with ink. Use a simple color palette of two or three colors. Add small tears to the banner to give it a weathered appearance.

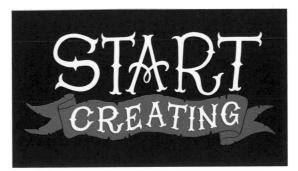

SOPHISTICATED NOIR

STYLE: Serif **WEIGHT:** Black **WIDTH:** Extended **CONTRAST:** Heavy

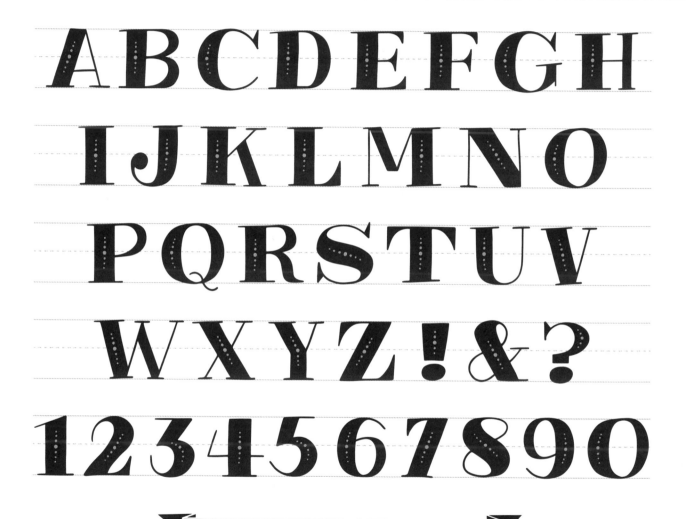

A B C D E F G H
I J K L M N O
P Q R S T U V
W X Y Z ! & ?
1 2 3 4 5 6 7 8 9 0

BASIC LETTERFORM CONSTRUCTION

Begin with a simple wireframe. Make the letter wide to account for its extended width.

Draw an extra thick vertical stem stroke, which is a defining characteristic of this alphabet.

Add thin horizontal strokes, and finish each arm with a prominent bracketed serif styling.

Trace over your sketch with black ink. Add some dot accents to the stem. The finished product should have a heavy contrast.

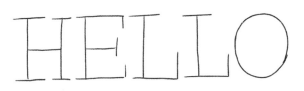

1 WIREFRAME

Start by drawing a simple wireframe of the word "HELLO." Each letter should be wide.

2 ROUGH SKETCH

Roughly sketch out each letterform. Focus on creating strong contrast in the stroke widths. The stem of each letterform should be thick and exaggerated when compared to the horizontal strokes. Add bracketed serifs to the arms of the letters "E" and "L."

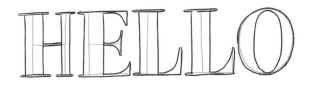

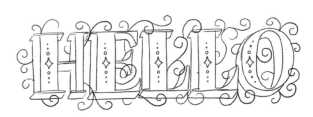

3 REFINE SKETCH

Once the rough sketch is in a good place, add dimensional drop shadow and some dot accents for inner letter detailing. To embellish the composition even further, draw some ornate flourishes around the lettering. These vines flourishes should curl.

4 COLORIZATION

To colorize your artwork, trace over your sketch with ink. Color the word "HELLO" in dark blue, and add a green drop shadow. Use a subdued color, such as gold, for the flourishes.

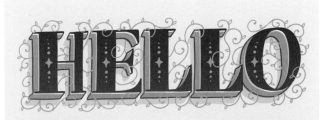

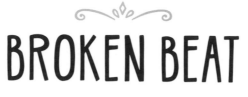

BROKEN BEAT

STYLE: Serif **WEIGHT:** Bold **WIDTH:** Regular **CONTRAST:** Medium

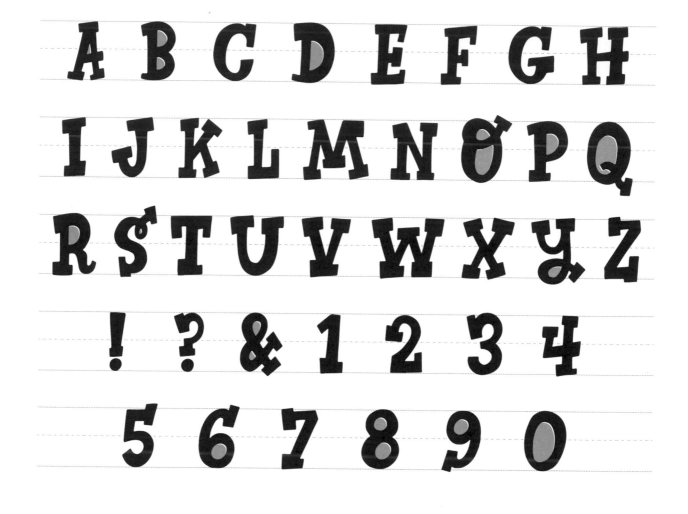

A B C D E F G H
I J K L M N O P Q
R S T U V W X Y Z
! ? & 1 2 3 4
5 6 7 8 9 0

BASIC LETTERFORM CONSTRUCTION

Begin with a basic wireframe. Keep it simple, as it will serve as a guide in future steps.

Visually break the letterform into a series of simple shapes, working left to right.

Add blocky slab serifs to the ends of each stroke. Use a mixture of stroke thickness for each serif.

Trace over your sketch with dark blue ink. The finished product should look misaligned and imperfect.

LETTERING COMPOSITION

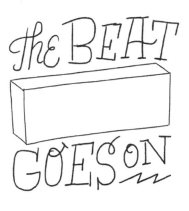

1 WIREFRAME

Start by drawing a dimensional rectangle in the center of your layout. Add simple wireframe lettering above and below the rectangular shape. Emphasize more important words by making them larger.

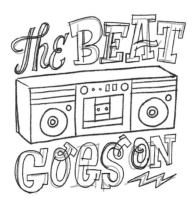

2 ROUGH SKETCH

Roughly sketch out each letterform. Allow the letterforms to vary in height and width, as this misalignment and imperfection is a characteristic of the featured alphabet. Add simple details to the boombox and a lightning bolt under the word "ON."

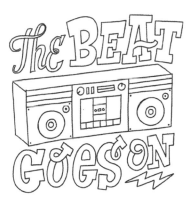

3 REFINE SKETCH

Trace over your rough sketch to clean up the linework and refine the composition. Add knobs and speakers to the boombox illustration.

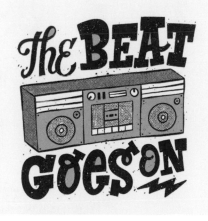

4 COLORIZATION

To colorize your artwork, trace over your sketch with ink. Use a simple color palette with two or three colors at most. Primary colors, such as blue and yellow, make this artwork pop. Add distressed texture to give the piece a vintage look.

BROKEN TATTOO

STYLE: Serif **WEIGHT:** Medium **WIDTH:** Regular **CONTRAST:** None

A B C D E F G H
I J K L M N O P Q
R S T U V W X Y Z
! ? & 1 2 3 4
5 6 7 8 9 0

BASIC LETTERFORM CONSTRUCTION

Begin with a basic wireframe. Capture the characteristics shown in the alphabet above.

Draw a shaky stem and a horizontal stroke to serve as the foundation for the letterform.

Add slab serifs to the horizontal and vertical shapes. Finish the sketch with a strike-through accent midway up the stem of the letter.

Trace over your sketch with brown ink. The finished product should have shaky and imperfect linework.

Lettering Alphabets & Artwork

LETTERING COMPOSITION

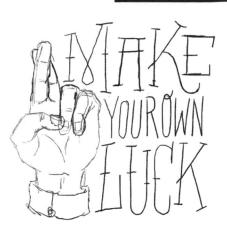

1 WIREFRAME

Start by drawing a rough illustration of a hand. Add wireframe lettering to the right of the hand. Emphasize more important words by drawing them large in and use the style of the featured alphabet. Draw less important words smaller and in a more basic sans serif lettering style.

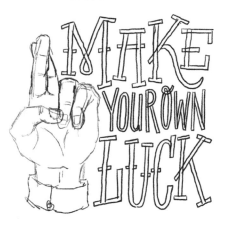

2 ROUGH SKETCH

Roughly sketch out each letterform, building up the thickness. Don't worry about making sure everything is aligned perfectly.

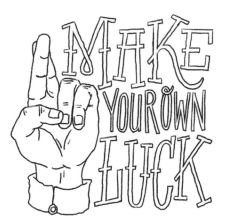

3 REFINE SKETCH

Refine the hand illustration by tracing over your rough sketch until you are happy with the outcome. Clean up each letterform until the messaging is clear and legible.

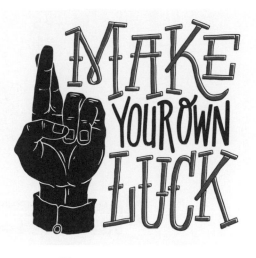

4 COLORIZATION

To colorize your artwork, trace over your sketch with ink. Use navy blue for the illustration and lettering linework. Add orange to the words "MAKE" and "LUCK" for emphasis.

WESTWARD WAGON

STYLE: Serif **WEIGHT:** Bold **WIDTH:** Condensed **CONTRAST:** Medium

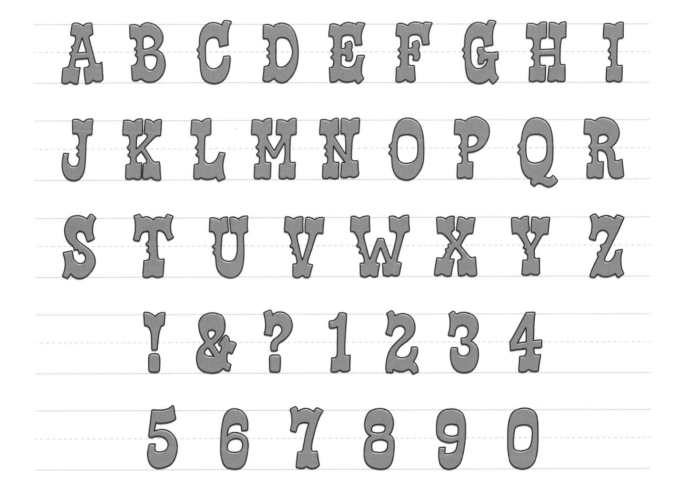

BASIC LETTERFORM CONSTRUCTION

Begin with a basic wireframe. Capture the curves and shapes shown in the alphabet above.

Break the letterform into a series of shapes, starting with the stem. Each stroke should have a slight curve.

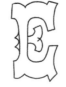

Add an ornamental serif to the arm of the letterform. Draw two small spurs midway up the stem.

Trace around the letterform to create a dark outlined stroke. Color the center of the letterform in orange.

LETTERING COMPOSITION

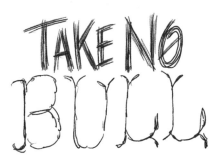

1 WIREFRAME

Start by drawing a wireframe of the word "BULL." Add lettering above the work in a scratchy style. Don't worry about keeping lines straight at this stage.

2 ROUGH SKETCH

Using the wireframe as a foundation, build out the thickness and style each letterform. Use a brush style for the top words. Use the featured ornamental serif alphabet as the style for the word "BULL."

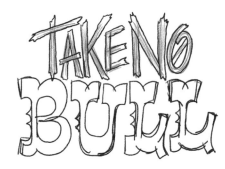

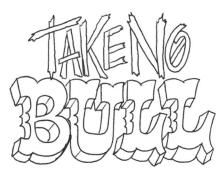

3 REFINE SKETCH

Once the rough sketch composition is in a good place, trace over your work to refine the lettering. Add a dimensional drop shadow to the word "BULL" for emphasis.

4 COLORIZATION

When the refined sketch is complete, trace over it with black ink. Use a simple palette of red and gold to color your lettering composition. Add a dotted inline to the word "BULL."

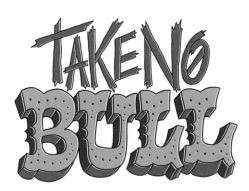

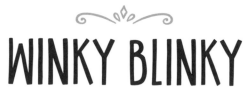

WINKY BLINKY

STYLE: Serif **WEIGHT:** Light **WIDTH:** Condensed **CONTRAST:** Medium

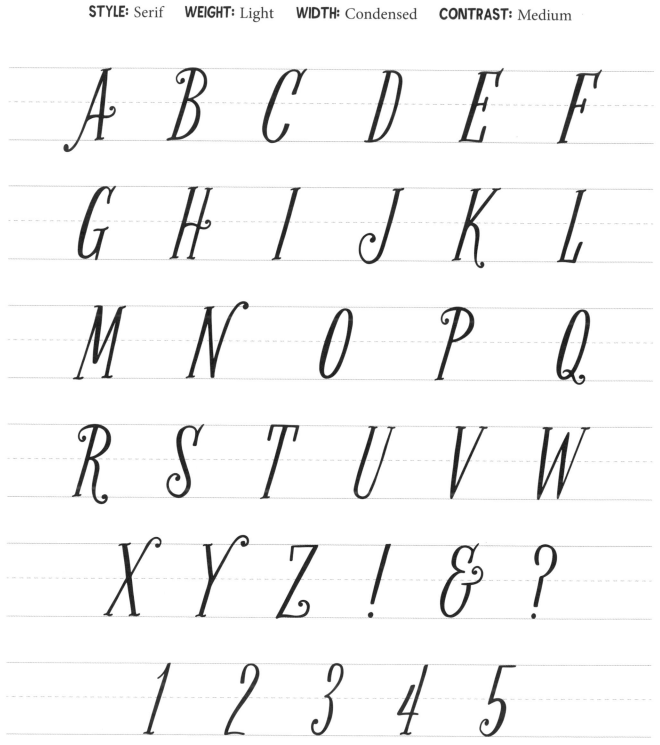

A B C D E F
G H I J K L
M N O P Q
R S T U V W
X Y Z ! & ?
1 2 3 4 5

a b c d e f g

h i j k l m n

o p q r s t

u v w x y z

6 7 8 9 0

Begin with a basic wireframe. Draw the letter on a slant, and keep the width condensed.

Start to build out the thickness of the letterform. Use a mixture of thick and thin strokes to provide variation in contrast.

Add a rounded serif to the bottom of the stem, and a flourished serif to the top of the stem.

Trace over your sketch with black ink. The final letterform should have a delicate, italic appearance.

PERFECT WAVE

STYLE: Serif **WEIGHT:** Black **WIDTH:** Regular **CONTRAST:** High

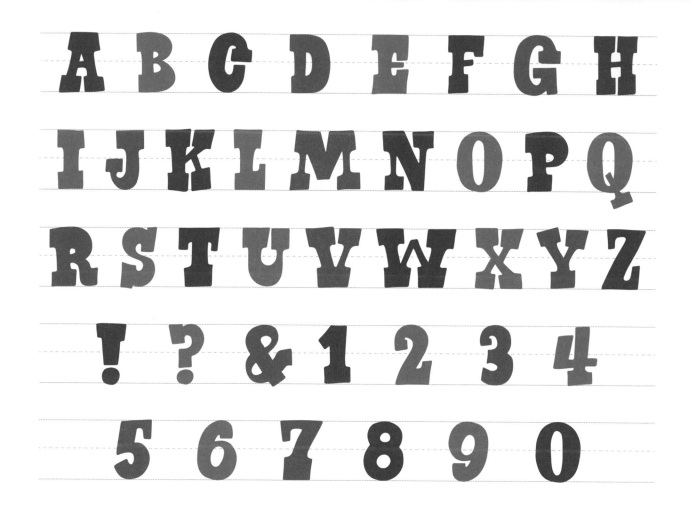

BASIC LETTERFORM CONSTRUCTION

Begin with a basic wireframe. Keep it simple, as it will serve as a guide in future steps.

Thicken the wireframe, and create strong contrast with thick and thin strokes.

Add chunky slab serifs to the ends of the stroke. Each serif can vary in terms of thickness.

Trace over your sketch with dark blue ink. Take your time, and use a steady hand during this final step.

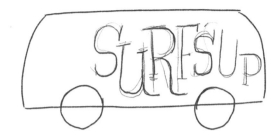

1 WIREFRAME

Draw a simple outline of the side of a van. Add wireframe lettering inside the shape. Don't worry about keeping lines straight or neat at this stage.

2 ROUGH SKETCH

Bring the van illustration to life with details such as windows and surfboards. Add bumpers, door handles, and rims to complete the look.

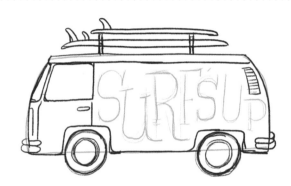

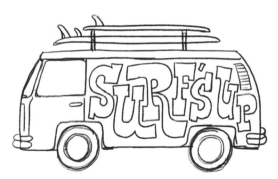

3 REFINE SKETCH

Next, start to thicken the letterforms. Fill in the entire shape of the van, adjusting each letterform as needed to make them fit.

4 COLORIZATION

To colorize your artwork, trace over your sketch with ink. Use dark ink for the van and brighter orange colors to make the lettering pop. Adding gritty texture emphasizes the vintage look.

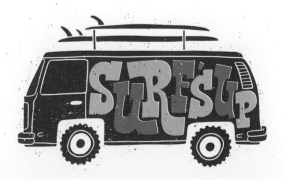

Serif Alphabets

81

FLIMSY WHIMSY

STYLE: Serif **WEIGHT:** Regular **WIDTH:** Regular **CONTRAST:** Light

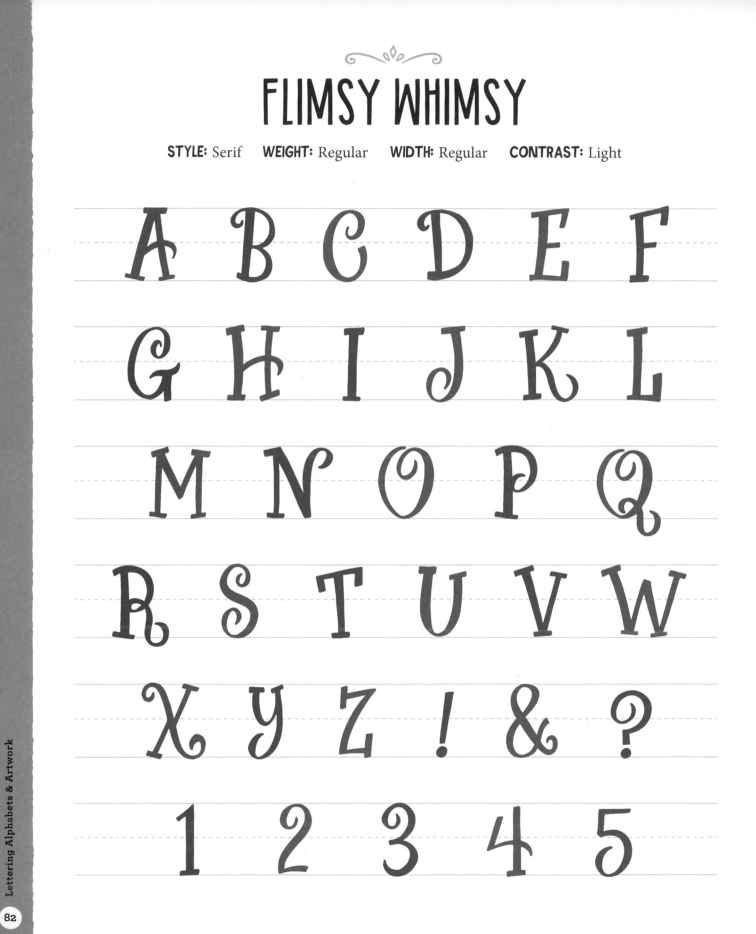

A B C D E F
G H I J K L
M N O P Q
R S T U V W
X Y Z ! & ?
1 2 3 4 5

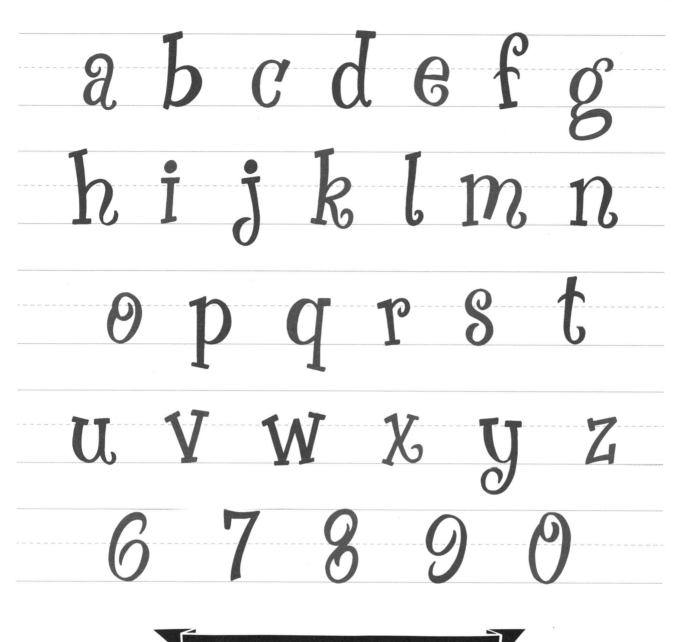

a b c d e f g
h i j k l m n
o p q r s t
u v w x y z
6 7 8 9 0

Begin with a basic wireframe that captures the bouncy energy of the alphabet style.

Build out the thickness. Draw a slanted and slightly curved stem shape.

Add two playful bowl strokes and a top serif with a flourish. Each stroke should vary in thickness.

Trace over your sketch with red ink. The final letterform should look energetic and playful.

LONELY MANSION

STYLE: Serif **WEIGHT:** Bold **WIDTH:** Condensed **CONTRAST:** Heavy

A B C D E F G H I
J K L M N O P Q R
S T U V W X Y Z
! & ? 1 2 3 4
5 6 7 8 9 0

BASIC LETTERFORM CONSTRUCTION

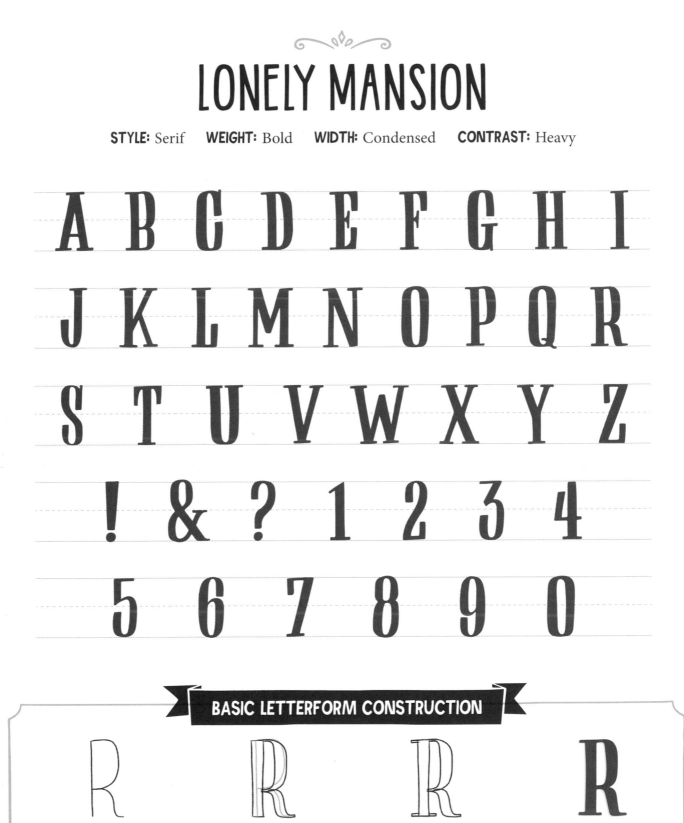

Begin with a basic wireframe. Keep it simple, as it will serve as a guide in future steps.

Draw the stem of the letterform first. Next, draw the bowl and leg. Vary the stroke thickness to create heavy contrast.

Add thin serifs to the stem of the letterform. The serif thickness should match the thickness of other horizontal strokes.

Trace over your sketch with dark green ink. The finished letterform should look compressed with small hairline serifs.

Lettering Alphabets & Artwork

1 WIREFRAME

Draw two slanted lines as a guide for your lettering. Use basic condensed wireframe lettering, stacked on two lines. Keep the lettering loose.

2 ROUGH SKETCH

Roughly sketch out the thickness of each letterform. Each letterform should have heavy contrast. Add vine flourishes above and below the lettering composition.

3 REFINE SKETCH

Using your rough sketch as a foundation to work from, trace each letterform until the linework is clean and ready to be inked. Add a drop shadow and some detail inside the letterforms.

4 COLORIZATION

To colorize your artwork, trace over your sketch with ink. Use a simple color palette of yellow, black, and white.

FAIRY TEARS

STYLE: Serif **WEIGHT:** Regular **WIDTH:** Regular **CONTRAST:** Medium

A B C D E F G H I

J K L M N O P Q R

S T U V W X Y Z

! & ? 1 2 3 4

5 6 7 8 9 0

Begin with a basic wireframe that captures the curvy style of this alphabet.

Break the letterform into a series of shapes, starting with the stem and bowl of the letter. Vary the stroke thickness to create contrast.

Add a leg and draw a rounded teardrop finial to the end of the stroke. Use the same styling for the top of the stem serif.

Trace over your sketch with dark purple ink. The finished product should feel whimsical.

LETTERING COMPOSITION

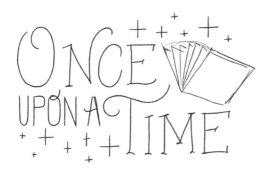

1 WIREFRAME

Sketch a phrase in a stacked configuration. Emphasize important words by making them larger. Add stars and a book illustration to highlight the fairy-tale theme.

2 ROUGH SKETCH

Roughly sketch each letterform. Use the featured alphabet for the words "ONCE" and "TIME." Use a simple sans serif style for the smaller, less important words.

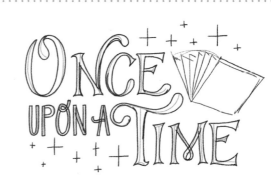

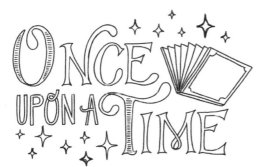

3 REFINE SKETCH

Once the rough sketch composition is in a good place, refine the lettering and illustration. Add inner detail to the letters "O" and "T." Add small and large stars to frame the composition.

4 COLORIZATION

To colorize your artwork, trace over your sketch with ink. Use a nighttime-themed color palette of blues, greens, and yellows.

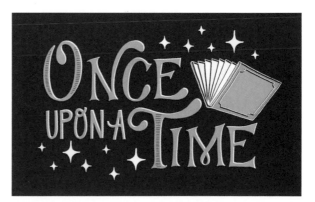

RAT IN A CAGE

STYLE: Serif **WEIGHT:** Regular **WIDTH:** Condensed **CONTRAST:** Medium

A B C D E F G H
I J K L M N O P Q
R S T U V W X Y Z
! ? & 1 2 3 4
5 6 7 8 9 0

BASIC LETTERFORM CONSTRUCTION

Begin with a basic wireframe. The letter should have a narrow appearance.

Break the letterform into a series of shapes, starting with the tapered stem.

Add the rest of the bowl shapes to the letterform, along with some rounded serifs at the top and bottom of the stem.

Trace over your sketch with black ink. Fill in the counters with bright red ink.

1 WIREFRAME

Start with basic wireframe lettering stacked on two lines. Emphasize important words by making them larger. Use a complementary lettering style like cursive for the smaller and less important words in the composition.

2 ROUGH SKETCH

Roughly sketch out the thickness of each letterform, starting with the larger words and finishing with the smaller cursive words. Don't worry about aligning each letter on the same baseline.

3 REFINE SKETCH

Once the rough sketch composition is in a good place, start refining. Using your rough sketch as a foundation, trace each letterform until the linework is clean and ready to be inked.

4 COLORIZATION

To colorize your artwork, trace over your sketch with ink. Use a simple palette of red and black to color your piece.

UTTERLY SHRILL

STYLE: Serif **WEIGHT:** Light **WIDTH:** Regular **CONTRAST:** Light

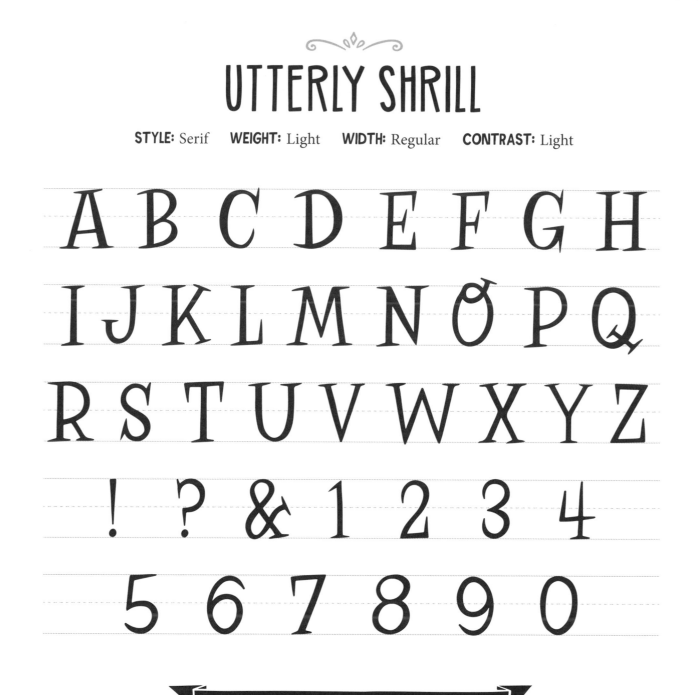

A B C D E F G H
I J K L M N O P Q
R S T U V W X Y Z
! ? & 1 2 3 4
5 6 7 8 9 0

BASIC LETTERFORM CONSTRUCTION

Begin with a basic wireframe. Keep it simple, as it will serve as a guide in future steps.

Break the letterform into a series of shapes. Draw the stem and diagonal strokes with a slight variation in thickness.

Add sharp, wide serifs to the ends of each stroke.

Trace over your sketch with dark blue ink. Take your time, and use a steady hand during this final step.

Lettering Alphabets & Artwork

LETTERING COMPOSITION

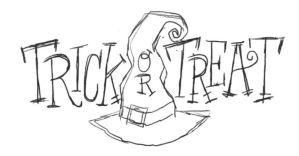

1 WIREFRAME

Start by drawing a crooked witch hat illustration. Add lettering to the left and right sides of the hat. The hat will hold the word "OR." Don't worry about keeping lines straight or neat at this stage

2 ROUGH SKETCH

Roughly sketch out each letterform. Each letter should take on the sharp feel of the featured serif alphabet. Add small bat illustrations to create a dynamic, spooky atmosphere.

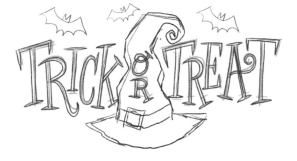

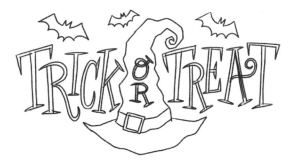

3 REFINE SKETCH

Once the rough sketch composition is in a good place, refine the lettering and clean up the linework.

4 COLORIZATION

To colorize your artwork, trace over your sketch with ink. Add gritty texture to give your composition a weathered appearance. Use a color palette of black and yellow to keep the design simple.

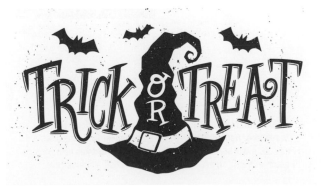

TRASH PANDA

STYLE: Serif **WEIGHT:** Black **WIDTH:** Regular **CONTRAST:** Light

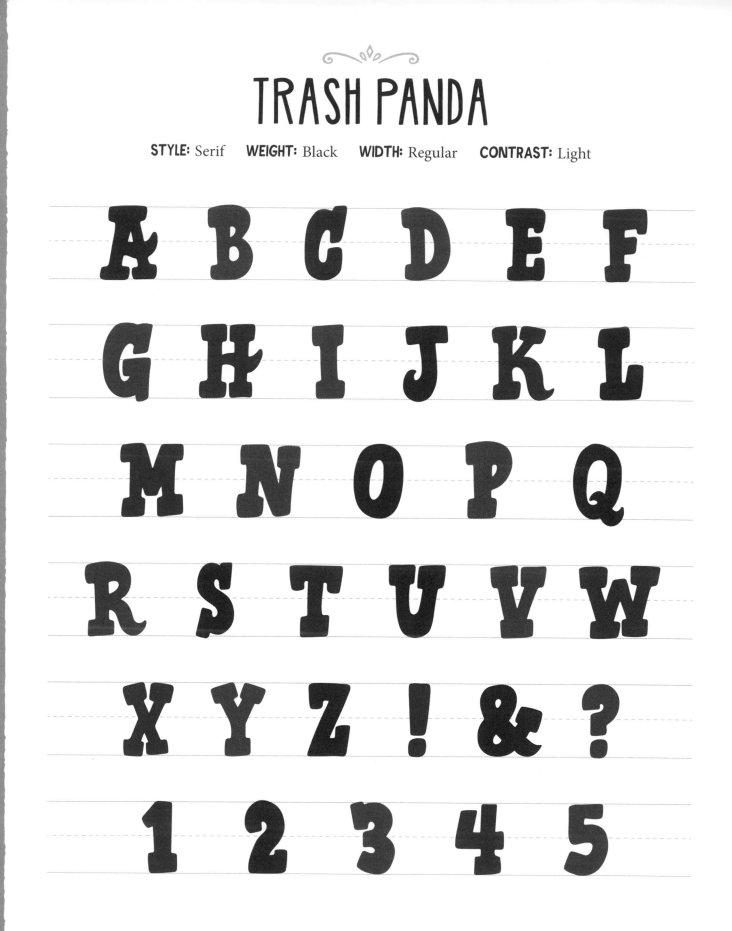

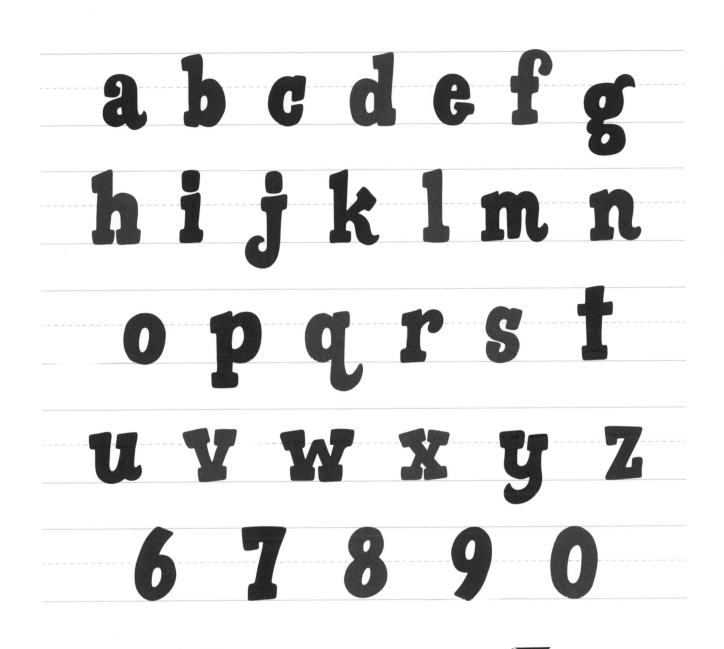

Begin with a basic wireframe. Keep it simple, as it will serve as a guide in future steps.

Visually break the letterform into a series of simple shapes, starting with the vertical strokes.

Add a swashy crossbar to the letterform and some rounded chunky serifs to the vertical strokes.

Trace over your sketch and color with dark gray ink. Take your time, and use a steady hand during this final step.

UPTOWN THIEF

STYLE: Serif **WEIGHT:** Bold **WIDTH:** Condensed **CONTRAST:** Heavy

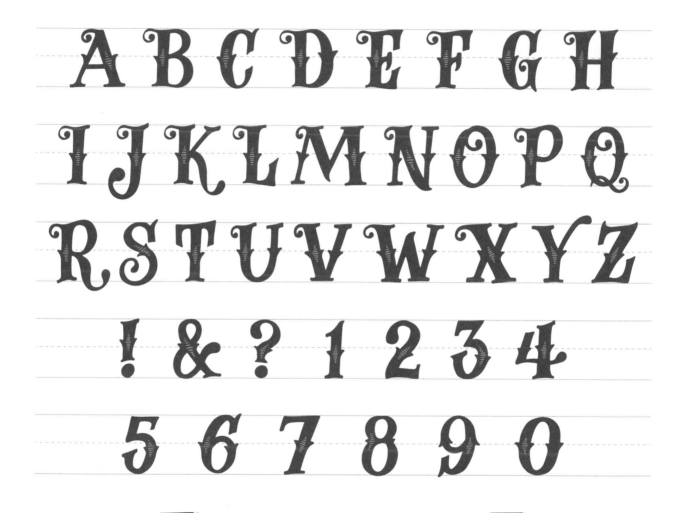

A B C D E F G H
I J K L M N O P Q
R S T U V W X Y Z
! & ? 1 2 3 4
5 6 7 8 9 0

BASIC LETTERFORM CONSTRUCTION

Begin with a basic wireframe. Keep it simple, as it will serve as a guide in future steps.

Break the letterform into a series of shapes, starting with the diagonal stems. One should be thin; the other should be thick.

Draw bracketed serifs to the bottoms of the diagonal strokes, and add a curled serif flourish to the apex. Add a spur midway up the letter on both sides.

Ink the letterform in green. Add inner detail to the wider diagonal stroke. The finished letterform should have a fairy-tale storybook feel.

1 WIREFRAME

Draw a simplified wireframe to use as the foundation. Capture the playful serif styling of this alphabet, but don't worry too much about making everything perfect at this stage.

2 ROUGH SKETCH

Begin roughly sketching out each letterform. Break down each letter into a series of shapes. The serifs should be bracketed, with an occassional flourish in place of a serif to add visual interest.

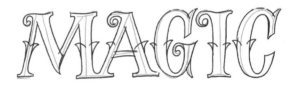

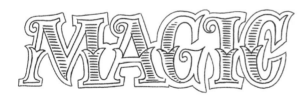

3 REFINE SKETCH

Once the rough sketch composition is in a good place, trace over your lettering to refine the linework. Add an outline around the entire lockup, along with some inner lettering detail.

4 COLORIZATION

To colorize your artwork, trace over your sketch with ink. Use a mixture of blue, green, and yellow for your color palette. Position the artwork on a light blue background to make it pop.

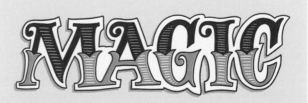

EERIE HOWL

STYLE: Serif **WEIGHT:** Regular **WIDTH:** Regular **CONTRAST:** Medium

A B C D E F G H
I J K L M N O P Q
R S T U V W X Y Z
! ? & 1 2 3 4
5 6 7 8 9 0

BASIC LETTERFORM CONSTRUCTION

Begin with a basic wireframe that captures the curved energy of the alphabet above.

Break the letterform into a series of shapes. Start by drawing a curved stroke with varying thickness.

Add the rest of the shapes to the letterform. The end of each stroke should have a curled and pointy appearance.

Trace over your sketch with dark ink. Take your time, and use a steady hand during this final step.

LETTERING COMPOSITION

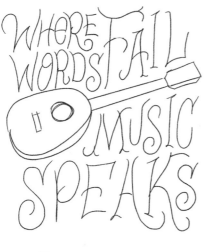

1 WIREFRAME

Draw a simple guitar shape. Add wireframe lettering above and below the guitar. Use a mixture of large and small words in your lettering composition. Don't worry about making this step look perfect.

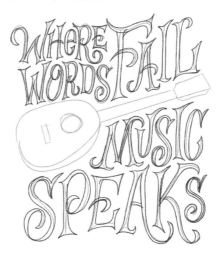

2 ROUGH SKETCH

Roughly sketch out each letterform. The style of the letterforms should reflect the curvy and sharp characteristics of the featured alphabet.

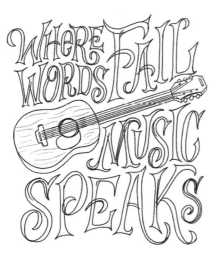

3 REFINE SKETCH

Once the rough sketch composition is in a good place, trace over it to clean up the linework in your lettering. Tighten up the guitar illustration and add strings and knobs.

4 COLORIZATION

To colorize your artwork, trace over your sketch with ink. Use a simple color palette of dark brown and gold. Add gritty texture to provide a vintage look.

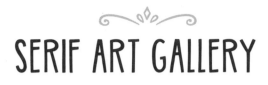

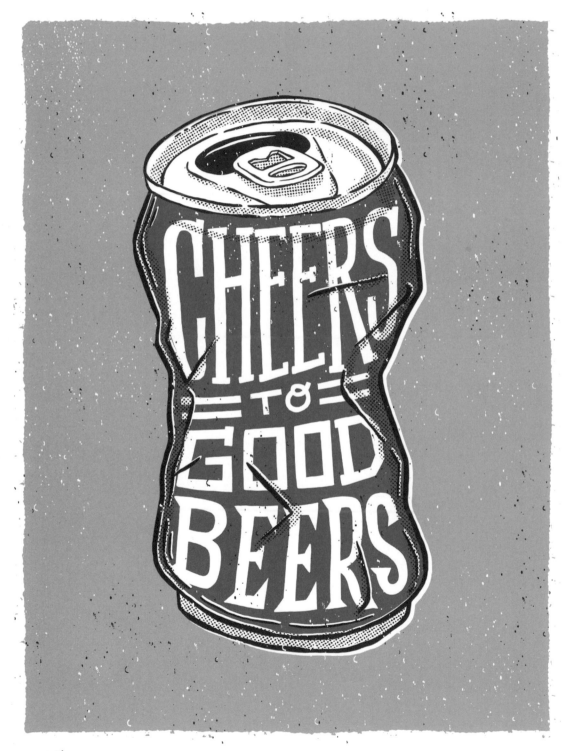

▲ Above
Cheers
By Jay Roeder

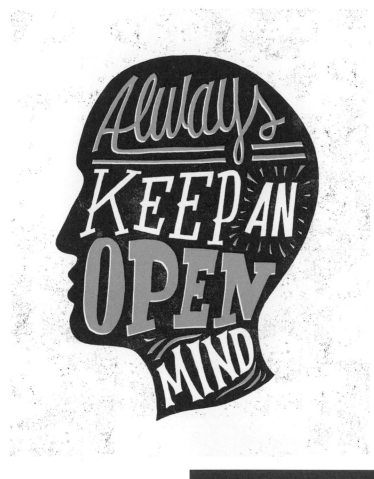

◄ Left
Open Mind
By Jay Roeder

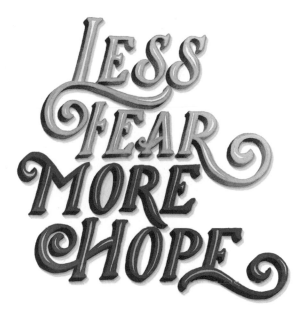

▼ Below
Less Fear More Hope
By João Neves
Client: Vodafone
Agency: J. Walter Thompson

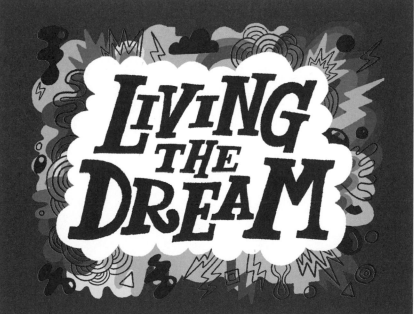

► Right
Living the Dream
By Matthew Taylor Wilson

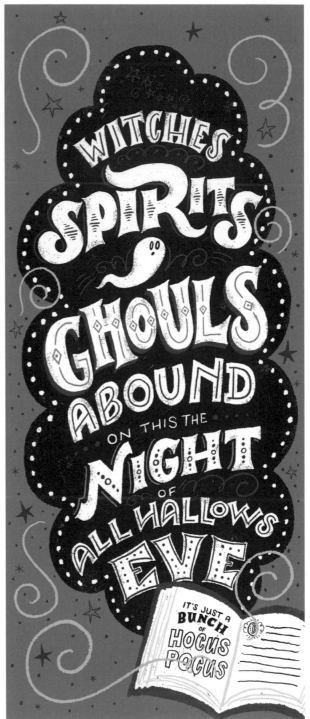

◀ Left
Follow Heart
By Tatak Waskitho

▲ Above
Insight
By Joel Felix

▲ Above
Hallow's Eve
By Shauna Lynn Panczyszyn

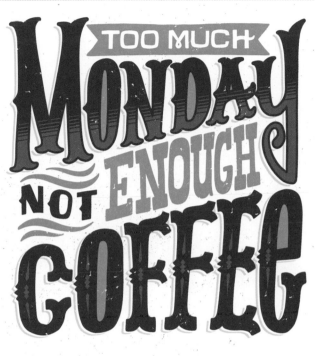

TOO MUCH
MONDAY
NOT ENOUGH
COFFEE

You
ARE TOO
GLAM
TO GIVE A
Damn

ADVENTURE
IS
OUT THERE

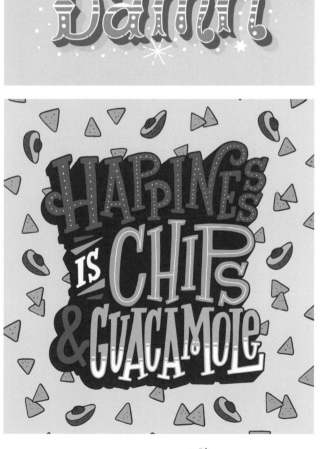

HAPPINESS
IS CHIPS
& GUACAMOLE

▲ Above
Adventure
By April Moralba

▲ Above
Chips & Guacamole
By Jay Roeder

Serif Alphabets

101

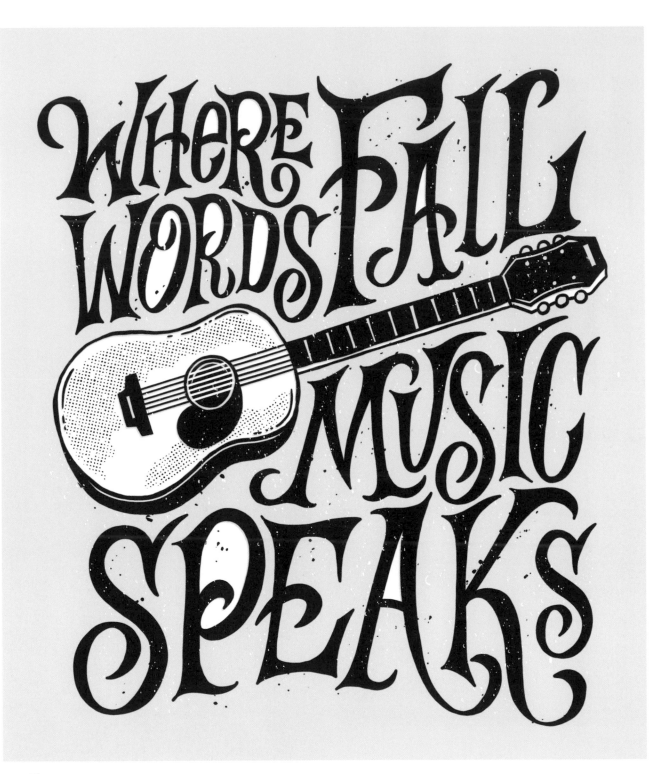

▲ Above
Music Speaks
By Jay Roeder

▲ Above
Happy Haunts
By Shauna Lynn Panczyszyn

___/250

▲ Above
Dreams
By Tatak Waskitho

▼ Below
Vote
By Cristina Vanko

▼ Below
Tacos
By Jay Roeder

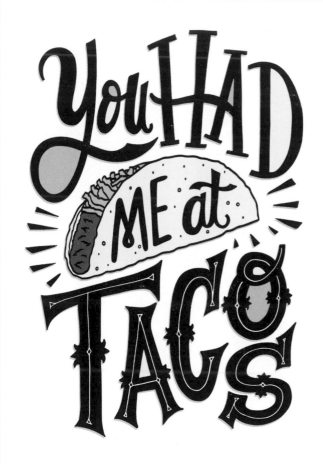

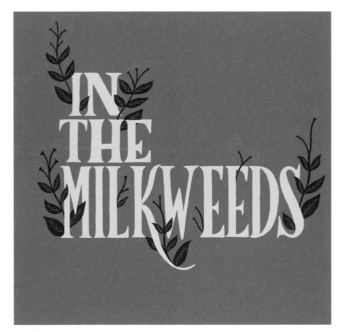

▲ Above
In the Milkweeds
By Cristina Vanko

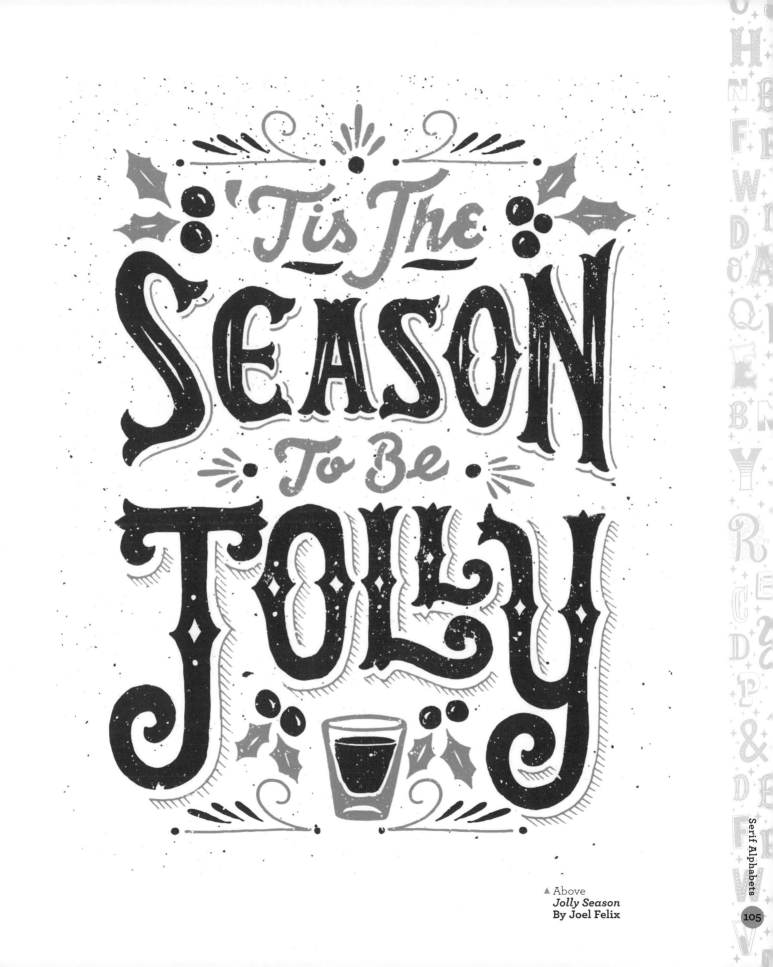

▲ Above
Jolly Season
By Joel Felix

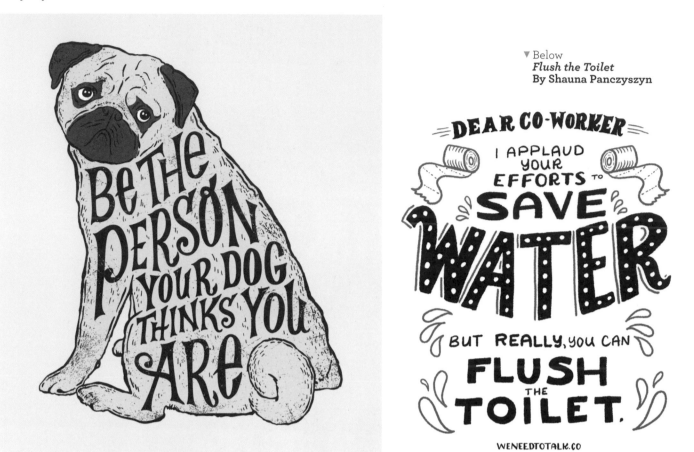

Be The PERSON YOUR DOG THINKS YOU ARE

▼ Below
Flush the Toilet
By Shauna Panczyszyn

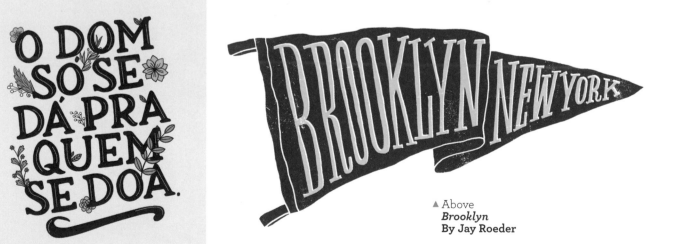

DEAR CO-WORKER
I APPLAUD YOUR EFFORTS TO SAVE WATER
BUT REALLY, YOU CAN FLUSH THE TOILET.

WENEEDTOTALK.CO

O DOM SÓ SE DÁ PRA QUEM SE DOA.

BROOKLYN NEW YORK

▲ Above
Brooklyn
By Jay Roeder

▲ Above
Não é Dom da Noite Pro Dia
By Julie Soresini

▶
Right
Stories of Time
By João Neves
Client: Sal. Oppenheim

SCRIPT
ALPHABETS

BARNYARD BRUSH

STYLE: Brush script **WEIGHT:** Black **WIDTH:** Extended **CONTRAST:** None

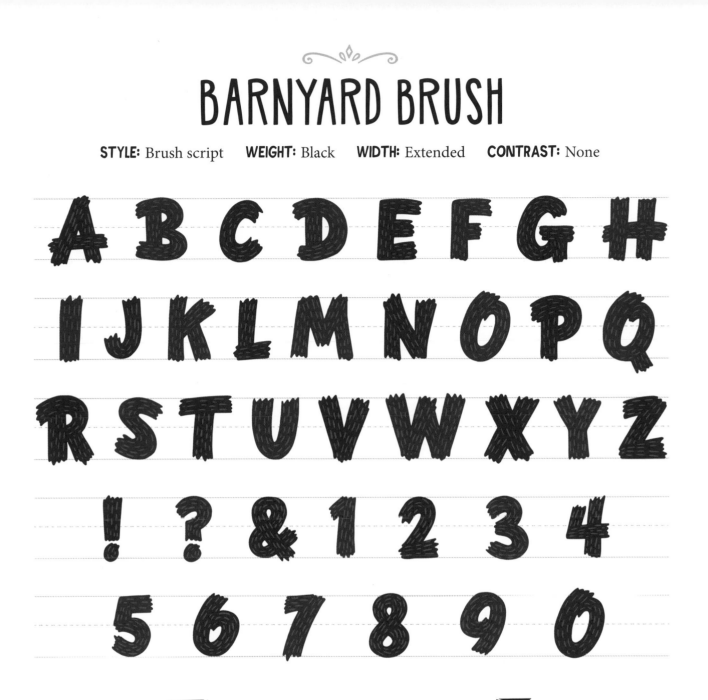

BASIC LETTERFORM CONSTRUCTION

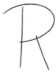

Begin with a basic wireframe that captures the defining the playfulness of this alphabet.

Break the letterform into a series of shapes. Start by drawing a thick brushstroke-like stem.

Add the rest of the shapes to the letterform. Finish each stroke with a jagged brush-like styling.

Trace over your sketch with brown ink. Add small light brown dashes that follow the direction of each stroke inside the letterform.

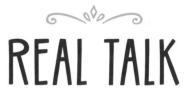

REAL TALK

STYLE: Cursive script **WEIGHT:** Regular **WIDTH:** Regular **CONTRAST:** Medium

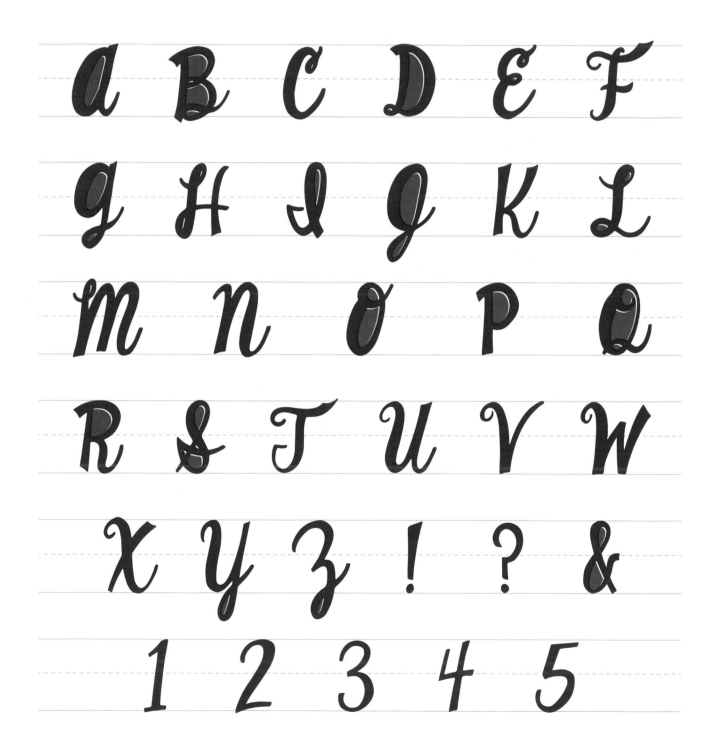

a b c d e f g

h i j k l m n

o p q r s t

u v w x y z

6 7 8 9 0

BASIC LETTERFORM CONSTRUCTION

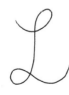

Begin with a basic
wireframe. Starting at
the top, draw the letter in
one fluid stroke.

Thicken the stem of the
letterform first. Taper the
stroke at both ends.

Add thin horizontal strokes to
finish the sketched letterform.
Make sure the letterform has a
mixture of thick and thin strokes.

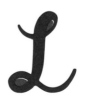

Trace over your sketch with
black ink. Fill in the counters
with a pop of magenta.

PRACTICALLY SCREAMING

STYLE: Brush script **WEIGHT:** Regular **WIDTH:** Regular **CONTRAST:** None

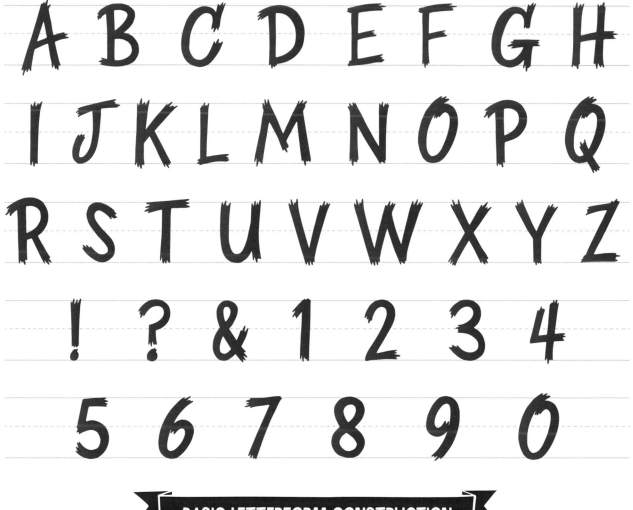

A B C D E F G H
I J K L M N O P Q
R S T U V W X Y Z
! ? & 1 2 3 4
5 6 7 8 9 0

BASIC LETTERFORM CONSTRUCTION

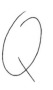

Begin with a basic wireframe. Keep this wireframe gestural to create a freeform look.

Break the letter into a series of shapes. Start by drawing the oval shape; then add the tail of the letter.

Add jagged brushstroke edges, which are a defining characteristic of this style.

Trace over your sketch with blue ink. Take your time, and use a steady hand during this final step.

LETTERING COMPOSITION

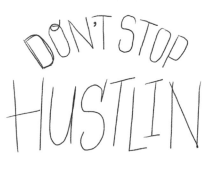

1 WIREFRAME

Start by drawing the word "HUSTLIN" as a wireframe. Add the words "DON'T STOP" above it, arranging the letters in an arch.

2 ROUGH SKETCH

Roughly sketch out the thickness of the word "HUSTLIN." The end of each stroke should have a jagged brushstroke appearance.

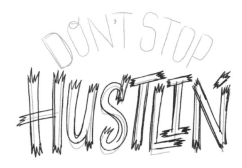

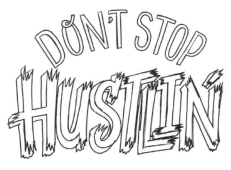

3 REFINE SKETCH

Once the rough sketch composition is in a good place, start refining and cleaning up the linework. Add a dimensional drop shadow behind the word "HUSTLIN.'"

4 COLORIZATION

To colorize your artwork, trace over your sketch with ink. Add a pop of magenta to emphasize the most important word, "HUSTLIN," and add a yellow background to draw attention to the composition.

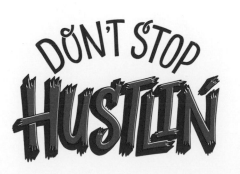

BUBBLEGUM STUD

STYLE: Brush script **WEIGHT:** Medium **WIDTH:** Regular **CONTRAST:** Light

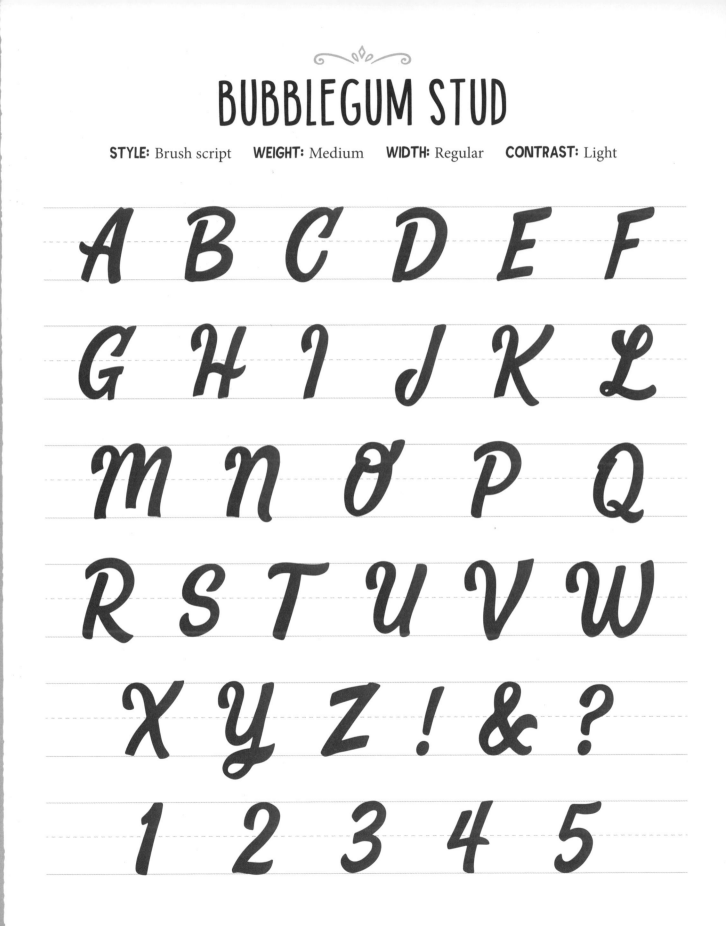

a b c d e f g
h i j k l m n
o p q r s t
u v w x y z
6 7 8 9 0

BASIC LETTERFORM CONSTRUCTION

Begin with a basic wireframe. Starting at the top, draw the letter in one fluid stroke.

Thicken the stem of the letterform first. Taper the stroke at both ends.

Add thin horizontal strokes to finish the sketched letterform. Make sure the letterform has a mixture of thick and thin strokes.

Trace over your sketch with magenta ink. Add a light gray shadow behind the letterform to add dimension.

OLDE BLACKBEARD

STYLE: Blackletter script **WEIGHT:** Medium **WIDTH:** Extended **CONTRAST:** Heavy

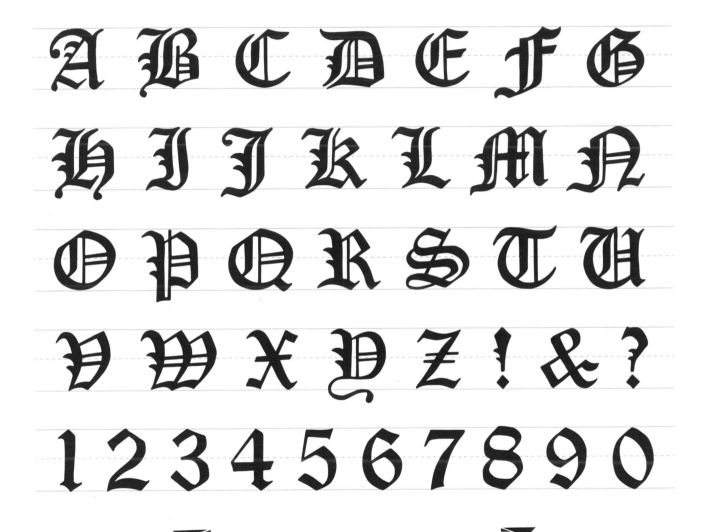

BASIC LETTERFORM CONSTRUCTION

Begin with a basic wireframe. Keep it simple, with an extended width.

Visually break the letter into a series of shapes. Pay close attention to the thickness of the letterform.

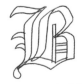

Add two spurs to the left-most stroke; then add two horizontal lines to the bottom right counter of the letter.

Trace over your sketch with black ink. Take your time with this final step.

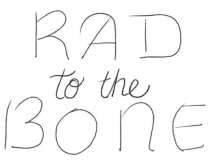

1 WIREFRAME

Draw a wireframe of a simple phrase. Enlarge and isolate more important words for emphasis. Introduce a cursive style for the less important words.

2 ROUGH SKETCH

Roughly sketch out the thickness of each letterform. Use the featured blackletter alphabet for the larger words. Start with vertical strokes to build out each blackletter. Use a mixture of thick and thin strokes to create contrast.

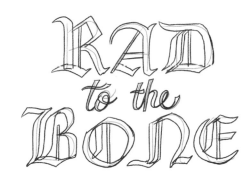

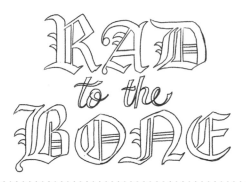

3 REFINE SKETCH

Once the rough sketch and basic letterforms are in a good place, start cleaning up the linework. Add spurs midway up the letters.

4 COLORIZATION

To colorize your artwork, trace over your sketch with ink. Use black for the letters, and fill in the counters with bright magenta to give your composition a modern feel.

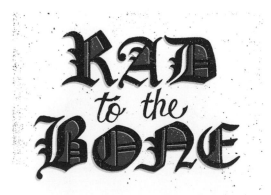

MIDNIGHT CONFESSION

STYLE: Cursive script **WEIGHT:** Light **WIDTH:** Regular **CONTRAST:** Medium

a b c d e f g
h i j k l m n
o p q r s t
u v w x y z
6 7 8 9 0

BASIC LETTERFORM CONSTRUCTION

Begin with a slanted cursive wireframe. Draw curled ends on each stroke.

Start to build out the thickness of the letterform. Use a mixture of thick and thin strokes to provide variation in contrast.

Trace over your rough sketch, and add a shaky styling to your linework. Round the ends of each stroke.

Trace over your sketch with dark blue ink. The final letterform should have a shaky and vintage style.

SLOPPY CRAFT

STYLE: Brush script **WEIGHT:** Bold **WIDTH:** Condensed **CONTRAST:** Heavy

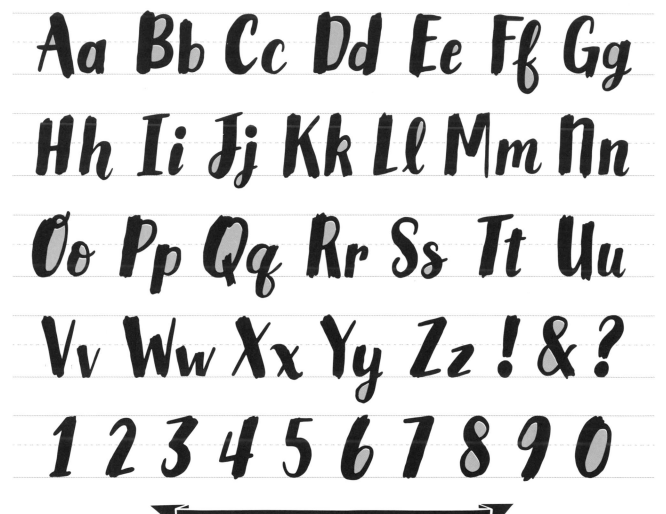

Aa Bb Cc Dd Ee Ff Gg
Hh Ii Jj Kk Ll Mm Nn
Oo Pp Qq Rr Ss Tt Uu
Vv Ww Xx Yy Zz ! & ?
1 2 3 4 5 6 7 8 9 0

BASIC LETTERFORM CONSTRUCTION

Begin with a basic wireframe. Keep it simple, as it will serve as a guide in future steps.

Break the letter into a series of shapes, starting with the vertical stem. Finish each stroke with a jagged edge.

Add two curved bowl strokes that are thinner than the thick vertical brushstroke.

Trace over your refined sketch with dark ink. Add green to each counter.

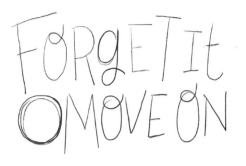

1 WIREFRAME

Start by drawing a simple wireframe. Draw a circular shape, which will hold an ampersand. Keep your linework loose.

2 ROUGH SKETCH

Build out each letterform by adding a mixture of thick and thin strokes to create a strong contrast. The ends of each stroke should have a jagged brushstroke-like edge. Convert the smooth circular shape into a pointy sun-like shape.

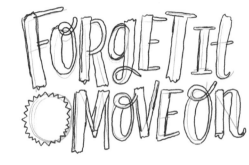

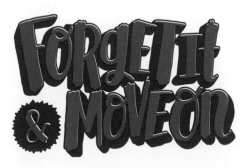

3 REFINE SKETCH

Clean up your lettering by tracing over the rough sketch. Add a dimensional drop shadow for emphasis. Draw an ampersand in the sun-like shape.

4 COLORIZATION

To colorize your artwork, trace over your sketch with ink. Use black ink for the lettering linework. Fill in each letter with a mixture of reds and pinks to create visual interest.

ANY OCCASION

STYLE: Brush script **WEIGHT:** Bold **WIDTH:** Condensed **CONTRAST:** Light

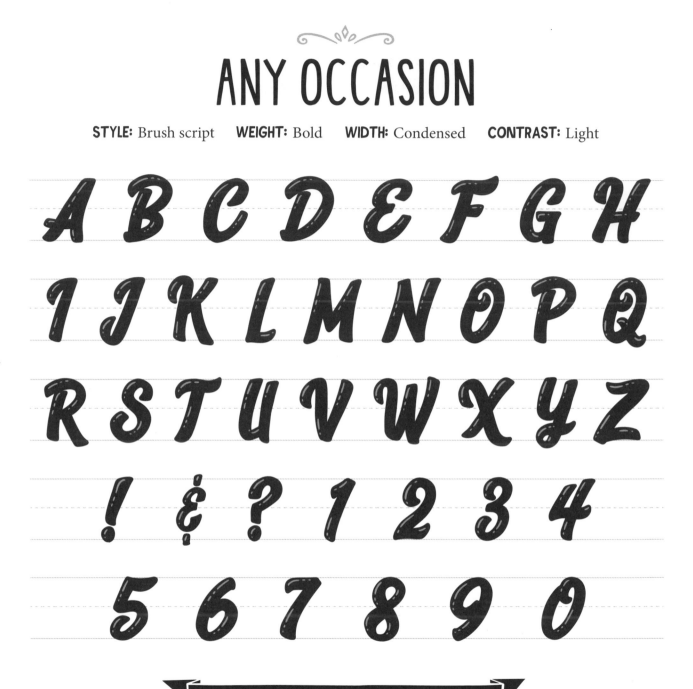

BASIC LETTERFORM CONSTRUCTION

Begin with a wireframe.
Start by drawing an oval
shape, then add a tail.

Visually break the
letterform into a series of
shapes, starting with the
outer oval shape.

Add a swashy tail to complete the
brush-style letterform. Make sure
the width of each stroke varies.

Trace over your sketch with
dark blue ink. Add additional
details in cyan to help give
the letterform dimension.

Lettering Alphabets & Artwork

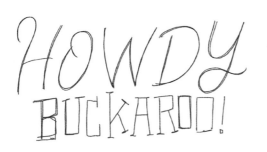

1 WIREFRAME

Draw the word "HOWDY" in a simple wireframe. Capture the playfulness of the cursive-inspired letterforms. Add "BUCKAROO" in a complementary serif lettering style below "HOWDY." Don't worry about keeping lines straight at this stage.

2 ROUGH SKETCH

Roughly sketch out the thickness of each letterform. Break down each letter into a series of shapes. The top word should take on the brush-inspired styling of the featured alphabet on page 122. Add swashy ascenders and descenders to the lettering.

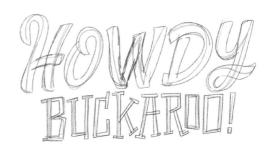

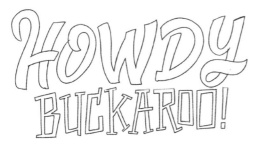

3 REFINE SKETCH

Trace over your sketch to refine your lettering and clean up the linework.

4 COLORIZATION

To colorize your artwork, trace over your sketch with ink. Use brown ink over a faded yellow background. Fill in the counters in the bottom word, and add some texture for visual interest.

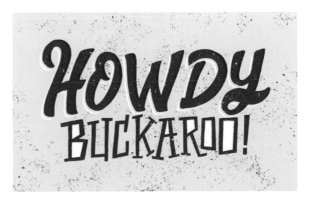

BUMPY ROAD

STYLE: Cursive script **WEIGHT:** Medium **WIDTH:** Regular **CONTRAST:** Light

A B C D E F
G H I J K L
M N O P Q
R S T U V W
X Y Z ! & ?
1 2 3 4 5

a b c d e f g
h i j k l m n
o p q r s t
u v w x y z
6 7 8 9 0

BASIC LETTERFORM CONSTRUCTION

Begin with a basic wireframe. Mimic the shaky styling of the featured alphabet.

Build out the thickness and draw the shaky-styled stem of the letterform. Add curled flourishes to the top and bottom.

Add a shaky diagonal stroke along with a curled leg to complete this letterform.

Trace over your sketch with purple ink. Focus on capturing the shaky quality of this alphabet.

DARKER TIDES

STYLE: Blackletter script **WEIGHT:** Bold **WIDTH:** Regular **CONTRAST:** Heavy

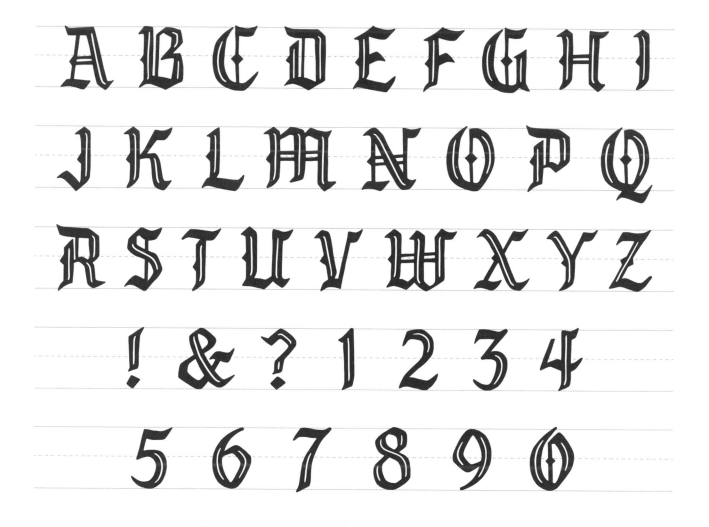

A B C D E F G H I
J K L M N O P Q
R S T U V W X Y Z
! & ? 1 2 3 4
5 6 7 8 9 0

BASIC LETTERFORM CONSTRUCTION

Begin with a basic wireframe. Keep it simple with sharp, angled serifs.

Break the letter into a series of shapes. Start with the diagonal stroke, building the letterform with thinner vertical strokes.

Add a pair of sharp serif shapes. Finish the letterform with two horizontal bars and a spur midway up the left vertical stem.

Trace over your sketch with black or dark gray ink. Add a white inline to the diagonal stroke.

LETTERING COMPOSITION

1 WIREFRAME

Draw a vertical rectangular shape; then draw a wireframe letterform inside.

2 ROUGH SKETCH

Roughly sketch out each stroke of the letterform. Start by drawing the left-most curved stroke, and add vertical strokes and serifs of varying thicknesses. Draw a shaky rectangle inside the first rectangular shape.

3 REFINE SKETCH

Trace over your sketch and clean up your linework. Add inner detailing to the letterform for visual interest. Complete the ornate look by adding curled flourishes to surround your letterform.

4 COLORIZATION

To colorize your artwork, trace over your sketch with ink. Use a simple color palette to prevent distraction from the detailed lettering composition.

FEED THE BEAST

STYLE: Brush script **WEIGHT:** Bold **WIDTH:** Condensed **CONTRAST:** Light

A B C D E F G H I

J K L M N O P Q

R S T U V W X Y Z

! & ? 1 2 3 4

5 6 7 8 9 0

BASIC LETTERFORM CONSTRUCTION

Begin with a basic wireframe. Draw the letter at a slant, and keep it loose.

Break the letter into a series of shapes. Start with the stem, and capture the jagged style of the alphabet shown above.

Add a rounded bowl, along with a jagged leg stroke. It's okay for the strokes to overlap one another.

Trace over your sketch with dark red ink. Add gradient shading to enhance the energetic look of the letterform.

1 WIREFRAME

Draw a simple wireframe of each letterform.
Draw the letters at a slant to give them energy.
Keep this sketch loose.

2 ROUGH SKETCH

Build out each letterform by breaking it down into
a series of shapes. Start by drawing the vertical
brushstrokes, adding jagged brush-like ends to them.
Taper the ends of each stroke to create contrast.

3 REFINE SKETCH

Once the rough sketch composition is in a good place,
use it as a guide and clean up your linework. Add an
extended drop shadow that angles to the lower right.

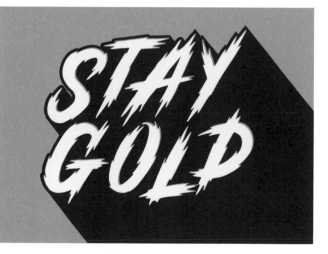

4 COLORIZATION

To colorize your artwork, trace over your sketch with ink.
Use a simple color palette of blue, gold, and black.

DARK SYMPHONY

STYLE: Blackletter script **WEIGHT:** Bold **WIDTH:** Condensed **CONTRAST:** Medium

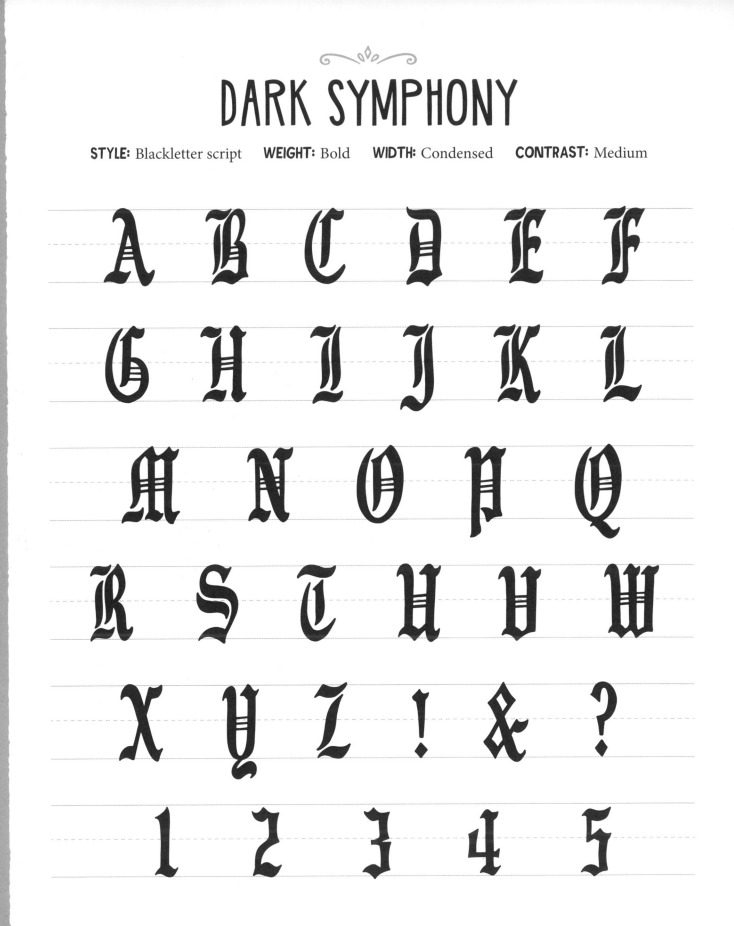

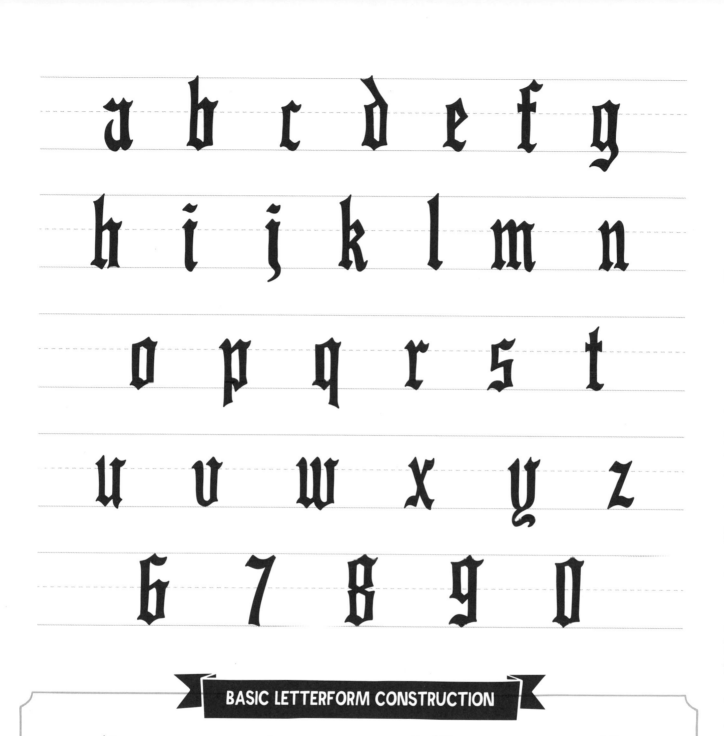

a b c d e f g

h i j k l m n

o p q r s t

u v w x y z

6 7 8 9 0

BASIC LETTERFORM CONSTRUCTION

Begin with a basic wireframe. Keep it simple with a condensed width.

Visually break the letter into a series of shapes. Pay close attention to the thickness and curvature of each stroke.

Finish the letter by adding horizontal strokes and a trio of small details in the middle of the letterform.

Trace over your sketch with black ink. The finished product should have a rounded look with heavy contrast.

SCRIBBLE SCRATCH

STYLE: Brush script **WEIGHT:** Medium **WIDTH:** Condensed **CONTRAST:** Medium

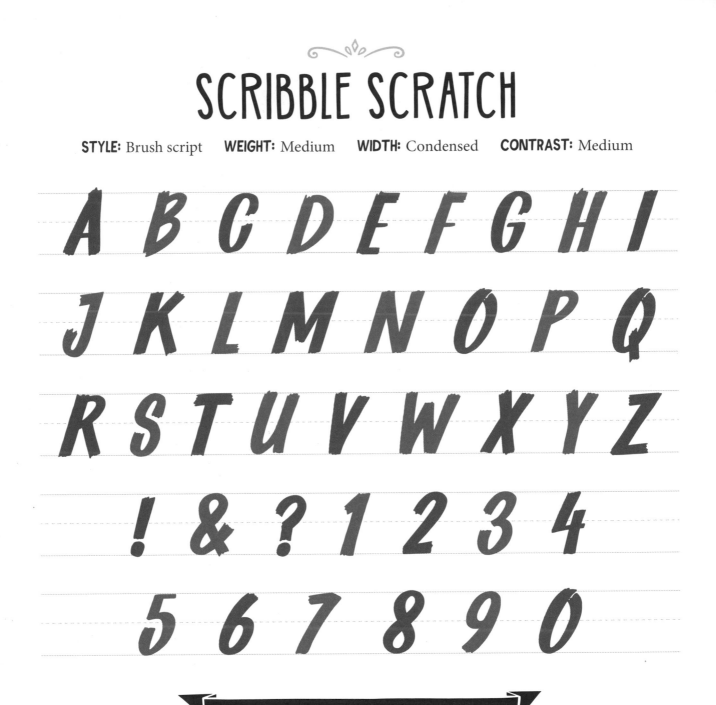

A B C D E F G H I
J K L M N O P Q
R S T U V W X Y Z
! & ? 1 2 3 4
5 6 7 8 9 0

BASIC LETTERFORM CONSTRUCTION

Begin with a basic angled wireframe. Keep it simple, as it will serve as a guide in future steps.

Start by drawing an angled vertical stem. Use a jagged edge at the beginning and end of all strokes.

Add a curved bowl, along with a diagonal leg stroke, to complete the letterform. Each stroke should have varying thickness.

Trace over your sketch with dark green ink. Take your time, and use a steady hand during this final step.

1 WIREFRAME

Draw a simple wireframe. Draw the letters at a slant to give them energy. Keep this sketch loose.

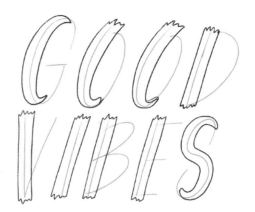

2 ROUGH SKETCH

Build out each letterform by breaking it down into a series of shapes. Start by drawing the vertical brushstrokes, adding jagged brush-like ends to them. Taper the ends of each stroke to add contrast.

3 REFINE SKETCH

Add the remaining curved and horizontal stroked shapes. Do not erase the overlaps, as you'll use these as guides for the colorization step.

4 COLORIZATION

To colorize your artwork, trace over your sketch with ink. Use three colors that are slightly translucent to create an overlapping effect.

YOU BETCHA

STYLE: Brush script **WEIGHT:** Bold **WIDTH:** Regular **CONTRAST:** Medium

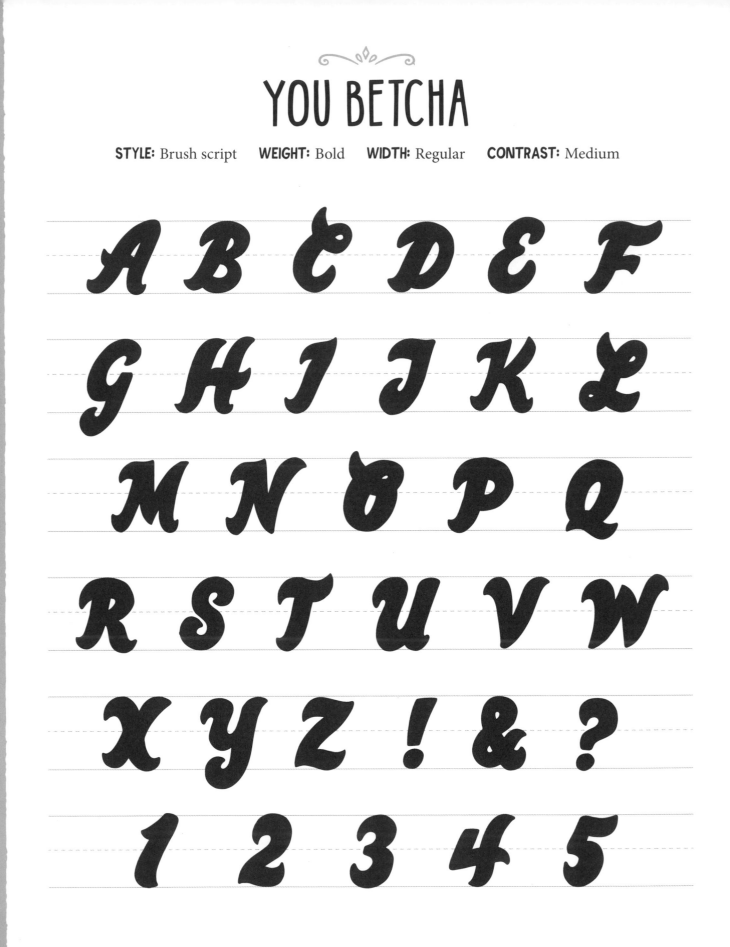

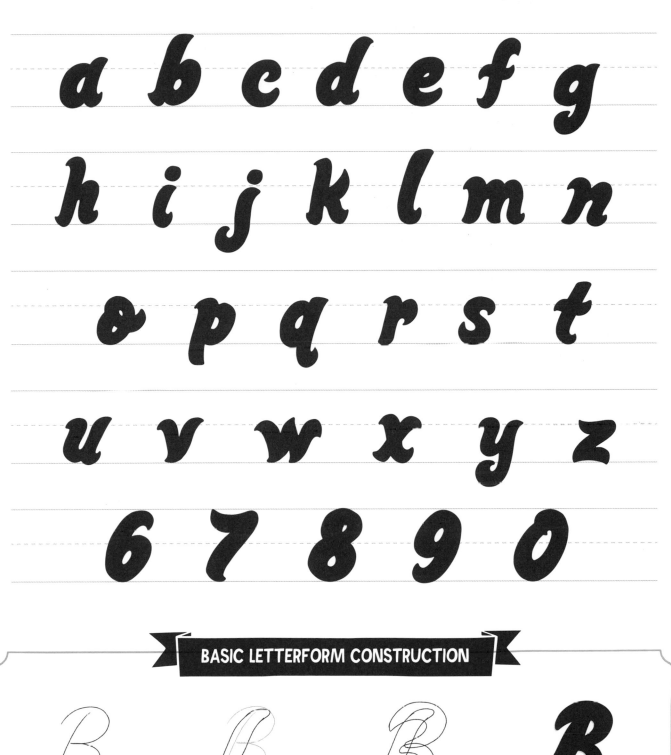

BASIC LETTERFORM CONSTRUCTION

Begin with a basic wireframe. Try to condense the width slightly.

Visually break the letter into a series of shapes. Start by drawing an angled, swashy vertical stem.

Finish the letter by adding two bowl shapes. Be sure to vary the stroke thickness.

Trace over your sketch with dark blue ink. The letterform should have a dynamic rounded brush-like styling.

LOST TIMES

STYLE: Cursive script **WEIGHT:** Regular **WIDTH:** Regular **CONTRAST:** Light

a b c d e f g

h i j k l m n

o p q r s t

u v w x y z

6 7 8 9 0

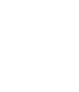

Begin with a basic wireframe. Starting at the top, draw the letter in one fluid stroke.

Thicken the stem of the letterform first. Break the letter into shapes to mimic a stencil style.

Finish the letter with a curved stroke at the top and bottom. Make sure the letterform has a mixture of thick and thin strokes.

Trace over your sketch with black ink. Add a light gray shadow behind the letterform to add dimension.

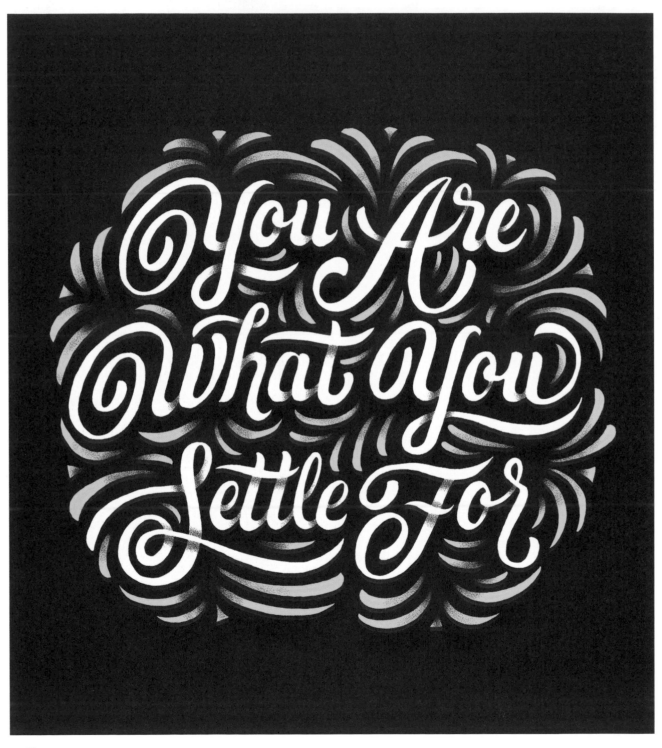

▲ Above
You Are What You Settle For
By João Neves

▼ Below
Feeling Better
By Nubikini

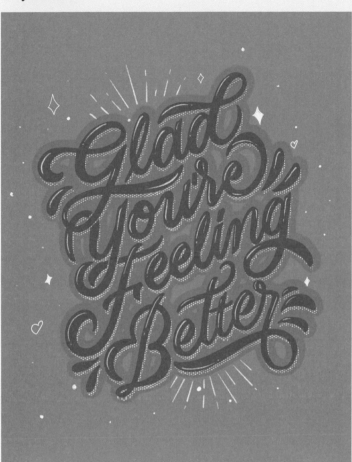

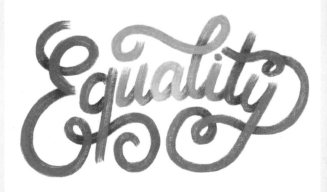

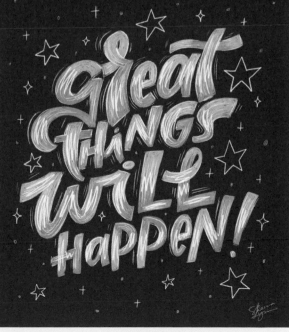

▲ Above
Equality
By Huyen Dinh

▲ Above
Great Things
By Shauna Lynn Panczyszyn

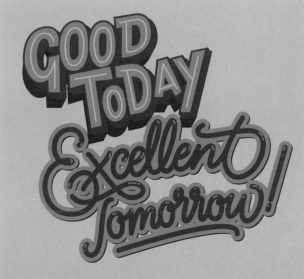

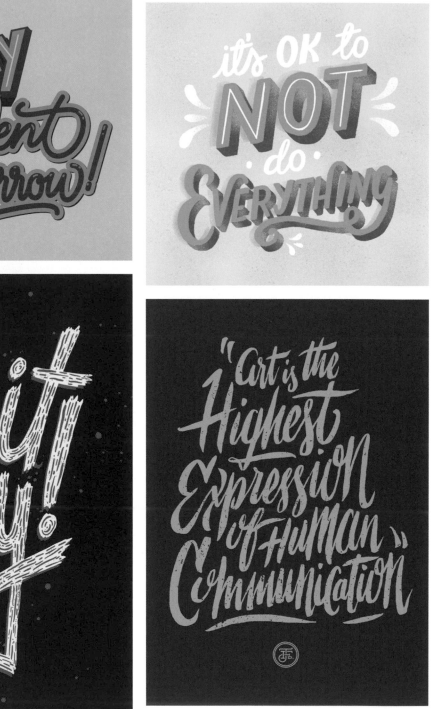

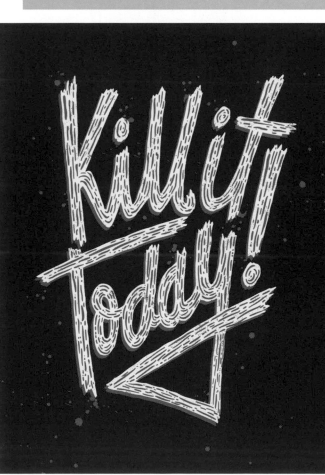

▲ Above
Kill It
By Jay Roeder

▲ Above
High Expression
By Joel Felix

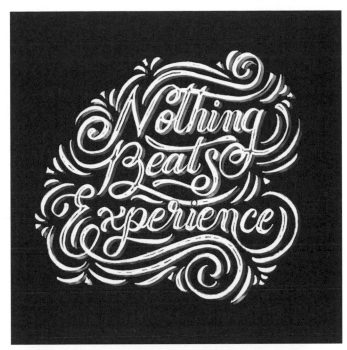

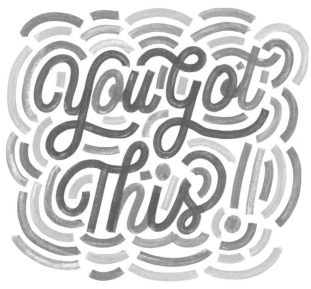

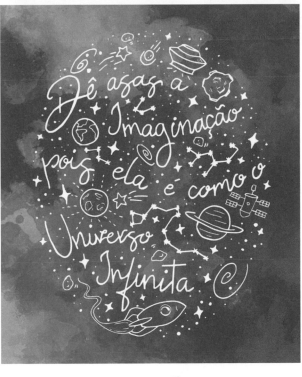

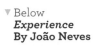

Script Alphabets

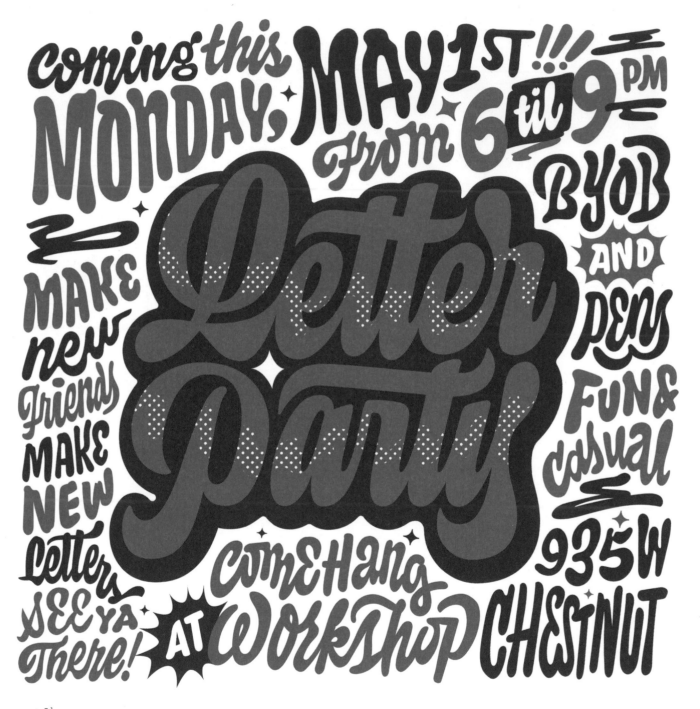

Coming this MONDAY, MAY 1ST!!! from 6 til 9 PM
Letter Party
MAKE new friends MAKE NEW Letters SEE YA There!
BYOB AND PEN FUN & casual
COME HANG AT WORKSHOP
935 W CHESTNUT

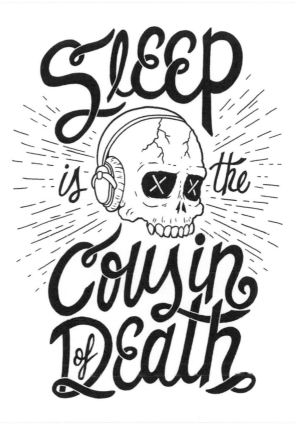

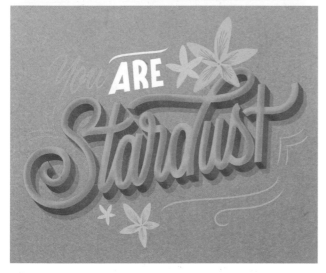

▲ Above
Stardust
By Nubikini

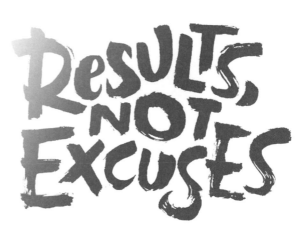

▲ Above
Results Not Excuses
By Angela Southern

Script Alphabets

143

▼ Below
Time Out
By Ian Barnard

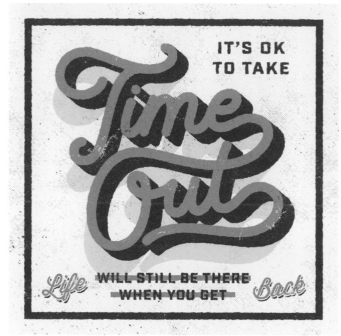

▼ Below
Girl Power
By Nubikini

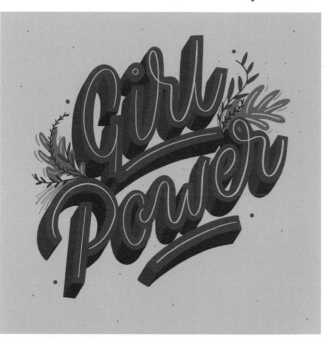

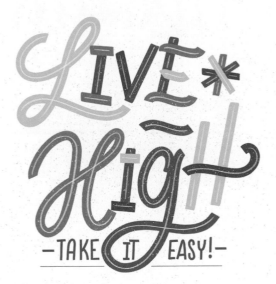

▲ Above
Live High
By Nubikini

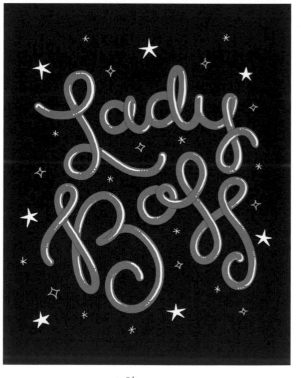

▲ Above
Lady Boss
By Shauna Lynn Panczyszyn

Lettering Alphabets & Artwork

▼ Below
On My Mind
By Matthew Taylor Wilson

▼ Below
Happy Haunting
By Shauna Lynn Panczyszyn

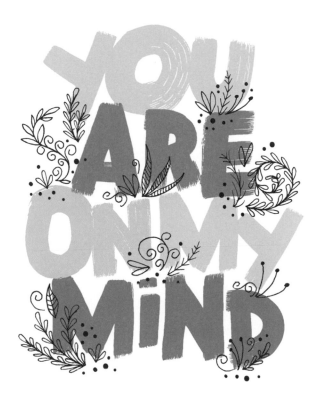

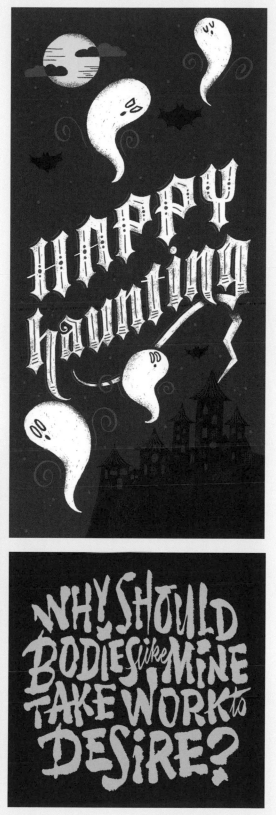

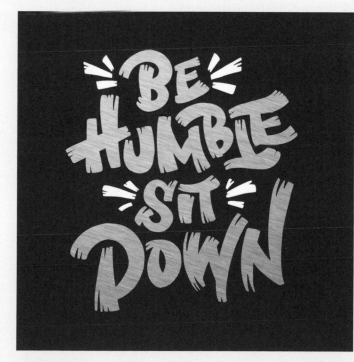

▲ Above
Be Humble
By April Moralba

▲ Above
Bodies Like Mine
By Kyle Letendre

Script Alphabets

145

DECORATIVE
ALPHABETS

ODDLY SHAPED

STYLE: Freestyle **WEIGHT:** Bold **WIDTH:** Regular **CONTRAST:** None

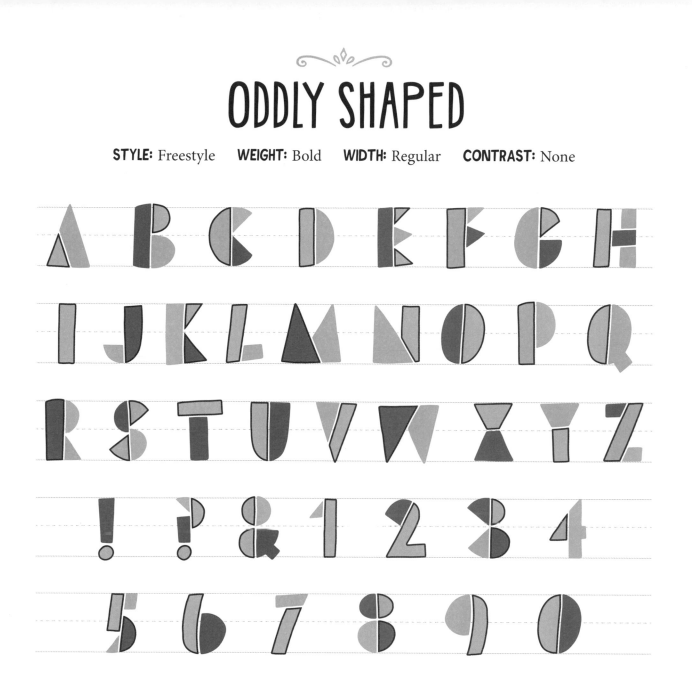

BASIC LETTERFORM CONSTRUCTION

Begin with a basic wireframe. Keep it simple, as it will serve as a guide in future steps.

Visually break the letterform down into a series of shapes. Start with a half circle on each side of the letterform.

Add the rest of the shapes to the letterform, along with an inner lining in the triangles.

Trace over your sketch using a trio of red, green, and blue.

ABANDONED BOXCAR

STYLE: Graffiti **WEIGHT:** Black **WIDTH:** Regular **CONTRAST:** Light

A B C D E F G
H I J K L M N
O P Q R S T U
V W X Y Z
! & ?

BASIC LETTERFORM CONSTRUCTION

Begin with a basic wireframe. Mimic the animated look of the featured alphabet above.

Visually break the letter into a series of shapes, starting with a curved stem shape.

Add a rounded upper bowl and a stylized leg.

Trace around your sketch in black ink. Add a gradient of orange and magenta coloring.

LETTERING COMPOSITION

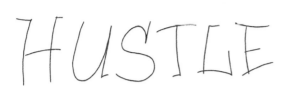

1 WIREFRAME

Start with a basic wireframe. Draw letterforms based on the alphabet on page 148.

2 ROUGH SKETCH

Roughly sketch out each letterform. Capture its playful nature by using curvy linework. Create each character by breaking the letterform down into shapes that vary in thickness.

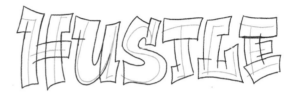

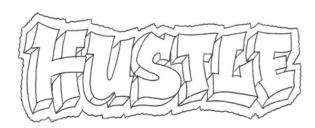

3 REFINE SKETCH

Once the rough sketch composition is in a good place, trace over your art to refine the linework. Add a dimensional drop shadow to each letterform, along with an outer stroke that surrounds the composition. Layering outlines and dimensional details adds an energetic effect to your artwork.

4 COLORIZATION

To colorize your artwork, trace over your sketch with ink. Use a bright color palette to ensure the lettering pops.

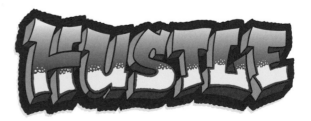

TWIGGIE SMALLS

STYLE: Representational **WEIGHT:** Medium **WIDTH:** Regular **CONTRAST:** Light

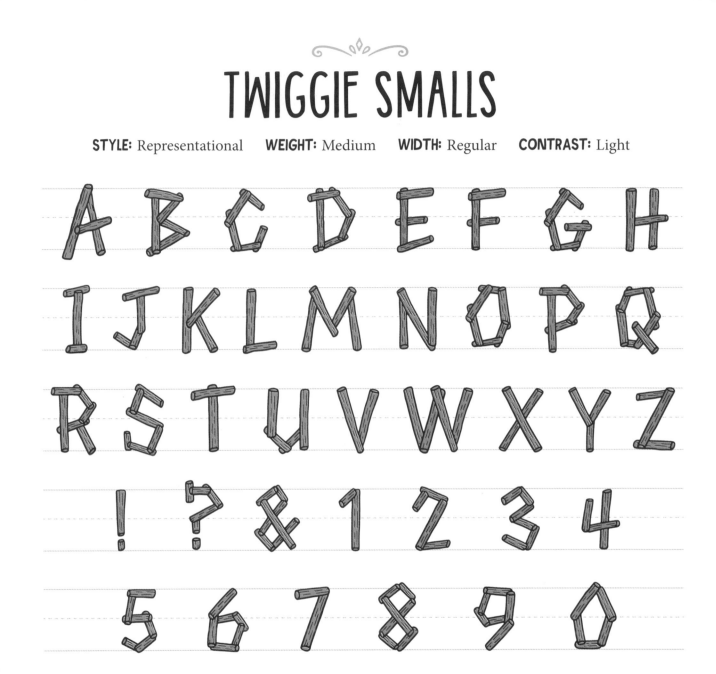

BASIC LETTERFORM CONSTRUCTION

Begin with a basic wireframe. Allow the strokes to overlap one another.

Draw each stroke as a cylindrical tube to mimic wooden twigs. Each shape should overlap.

To push the concept further, add small wood grains that follow the direction of each stroke.

Trace over your sketch with a dark brown outline. Color the center of each shape with a lighter brown.

① WIREFRAME

Start with a basic wireframe of two different lettering styles. Emphasize important words by making them larger.

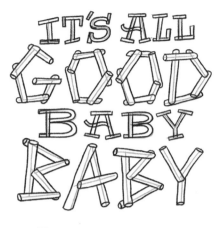

② ROUGH SKETCH

Roughly sketch out each letterform, keeping your lettering loose and free. Break up the words "GOOD" and "BABY" into a series of cylindrical twig shapes. Use an extended serif styling for the smaller words.

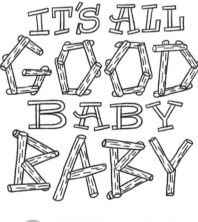

③ REFINE SKETCH

Once the rough sketch composition is in a good place, trace over your art to refine the linework. Add wood grain details to the the words "GOOD" and "BABY," to emphasize the wooden look of the letterforms.

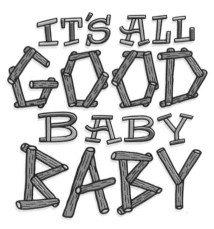

④ COLORIZATION

To colorize your artwork, trace over your sketch with ink. Use a simple color palette of oranges and browns.

RIBBONS FOR DAYS

STYLE: Representational **WEIGHT:** Medium **WIDTH:** Regular **CONTRAST:** Light

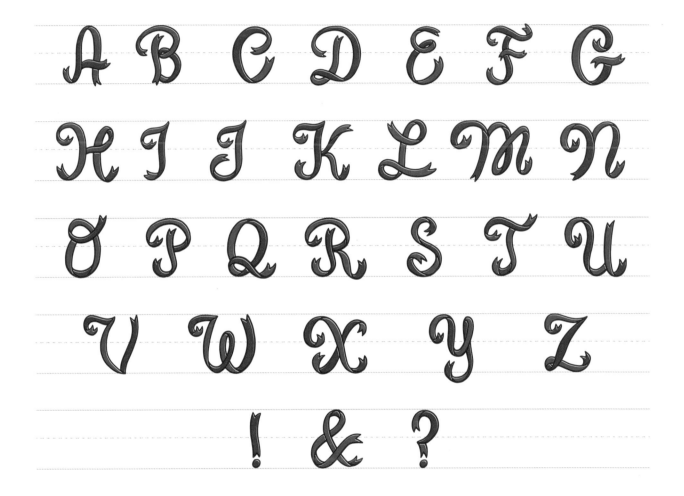

BASIC LETTERFORM CONSTRUCTION

Begin with a slanted cursive wireframe. Curl the ends of each stroke.

Draw the ribbon-like stem. Stylize each end of the ribbon.

Finish the letterform by adding a curved bowl and leg strokes. Each stroke should twist just like a real ribbon would.

Outline the letterform in black ink. Use light and dark shades of red to fill in each stroke.

LETTERING COMPOSITION

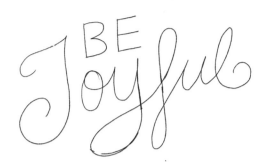

1 WIREFRAME

Draw a basic wireframe. Use two lettering styles that complement each other. Keep this sketch loose.

2 ROUGH SKETCH

Sketch out each letterform over your wireframe. Start with the larger word "JOYFUL" and fit the word "BE" neatly into the composition. Use freestyle lettering for the word "BE" and a cursive representational style for the word "JOYFUL."

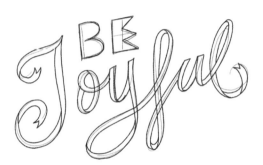

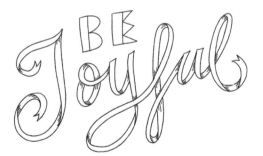

3 REFINE SKETCH

Once the rough sketch composition is in a good place, trace your work. Use a steady hand as your refine the linework. Add small shading details.

4 COLORIZATION

To colorize your artwork, trace over your sketch with ink. Use a color palette of black and two different tones of red.

PAPER RIOT

STYLE: Freestyle **WEIGHT:** Bold **WIDTH:** Condensed **CONTRAST:** Light

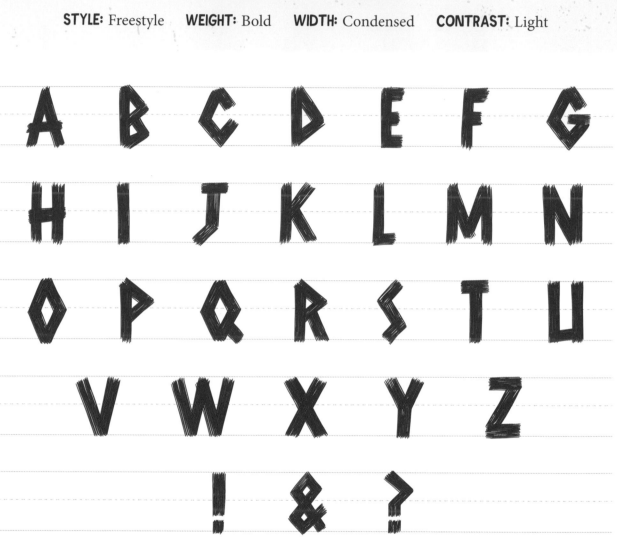

BASIC LETTERFORM CONSTRUCTION

Begin with a basic wireframe. Keep it simple, as it will serve as a guide in future steps.

Visually break the letter into a series of shapes. Start with the left stroke and add quick, scribbly strokes until the shape is roughly filled in.

Complete the letterform by adding the right scribble stroke, along with a crossbar that overlaps each diagonal stroke.

Trace over your sketch with magenta ink. In dark blue ink, trace over the same shape, but slightly offset the marks to allow the magenta to show through.

Lettering Alphabets & Artwork

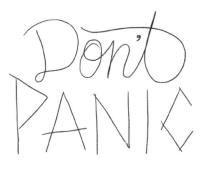

1 WIREFRAME

Start by drawing a basic wireframe. Draw the bottom larger word first; then add a second word above it in complementary cursive lettering.

2 ROUGH SKETCH

Roughly sketch out each letterform over your wireframe. Focus on the word "PANIC" first. Use quick strokes to create the letterform. Once the bottom word is filled out, focus on building out the thickness of the top word "DON'T."

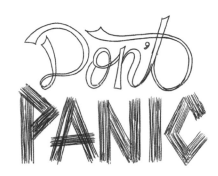

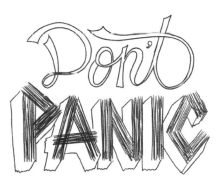

3 REFINE SKETCH

Once the rough sketch composition is in a good place, start to refine the linework. Add a dimensional shadow to the left side of each character of the word "PANIC."

4 COLORIZATION

To colorize your artwork, trace over your sketch with ink. Trace everything with black ink. Introduce a bright cyan coloring to the dimensional word. Use a bright yellow background to make the lettering pop.

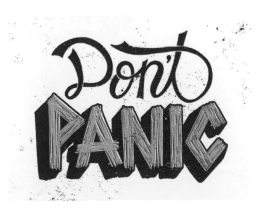

Decorative Alphabets

155

UNDER THE BRIDGE

STYLE: Graffiti **WEIGHT:** Bold **WIDTH:** Regular **CONTRAST:** Heavy

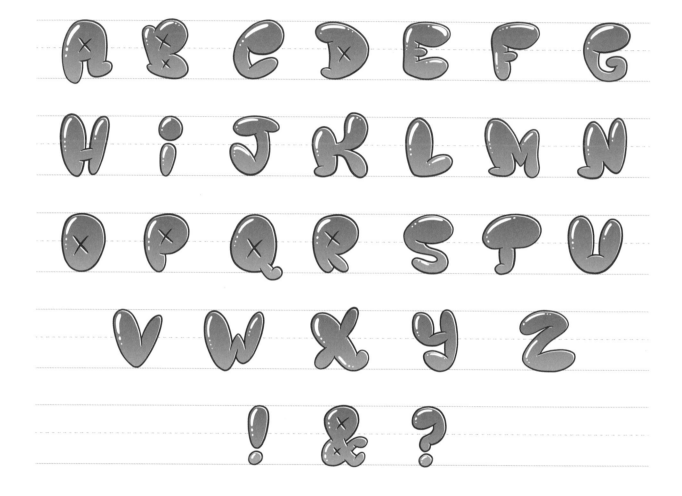

BASIC LETTERFORM CONSTRUCTION

Begin with a basic wireframe. Keep it simple, as it will serve as a guide in future steps.

Draw rounded linework around the wireframe. Add a leg that overlaps the stem and bowl shape.

Thicken the outline, and add an "X" in place of the counter. Add some glossy accent marks.

Trace over your sketch with a dark purple outline. Use a pink gradient to color the inside of the letterform. The glossy accents should be white.

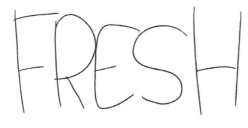

① WIREFRAME

Draw rounded wireframes to mimic the characteristics of the featured bubble-style graffiti alphabet on page 156.

② ROUGH SKETCH

Roughly sketch out each letterform, keeping your lettering loose and free. Use a round, inflated style to give it more personality. To make your lettering composition more dynamic, allow the letters to overlap. Add an outline around the composition.

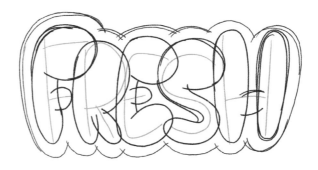

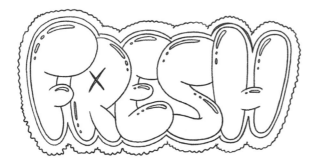

③ REFINE SKETCH

Once the rough sketch composition is in a good place, refine the linework. Add another outer stroke around the letters and some linework inside of each letterform to give it a three-dimensional look.

④ COLORIZATION

To colorize your artwork, trace over your sketch with ink. Use a bright green gradient inside the lettering and blue and black for the outlines.

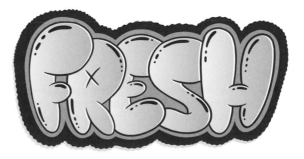

RUN WITH IT

STYLE: Freestyle **WEIGHT:** Bold **WIDTH:** Regular **CONTRAST:** None

A B C D E F G

H I J K L M N

O P Q R S T U

V W X Y Z

P ! &

Begin with a basic wireframe. Keep it simple, as it will serve as a guide in future steps.

Visually break the letter into a series of shapes. Start by drawing a thick stem.

Add a series of diagonal lines to form the leg of the letter. Add four more curved lines to form the bowl shape.

Trace over the stem shape in dark blue. Use magenta when drawing the lines that form the bowl and the leg.

LETTERING COMPOSITION

① WIREFRAME

Draw a basic wireframe. Use a simple phrase, such as "HAPPY DAYS," and break it down into three rows of stacked letters. Keep the letters simple.

② ROUGH SKETCH

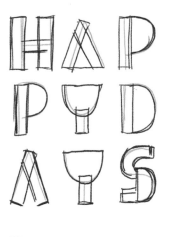

Using the wireframe foundation as a guide, roughly sketch out each letterform. Break each letterform into the geometric shapes that are the defining characteristics of the freestyle alphabet on page 158.

③ REFINE SKETCH

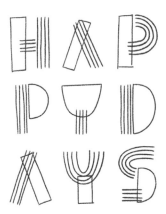

Once the rough sketch composition is in a good place, add more detail to the lettering. Each letterform should consist of a combination of shapes and lines. Allow the lines to overlap the geometric shapes.

④ COLORIZATION

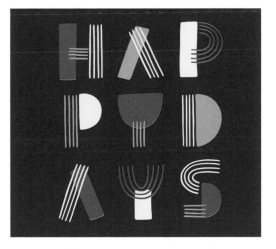

To colorize your artwork, trace over your sketch with ink. Use a bright color palette of cyan, magenta, and yellow on a black background. Evenly saturate the colors so they are balanced.

PARADOXICAL DANCE

STYLE: Freestyle **WEIGHT:** Bold **WIDTH:** Condensed **CONTRAST:** None

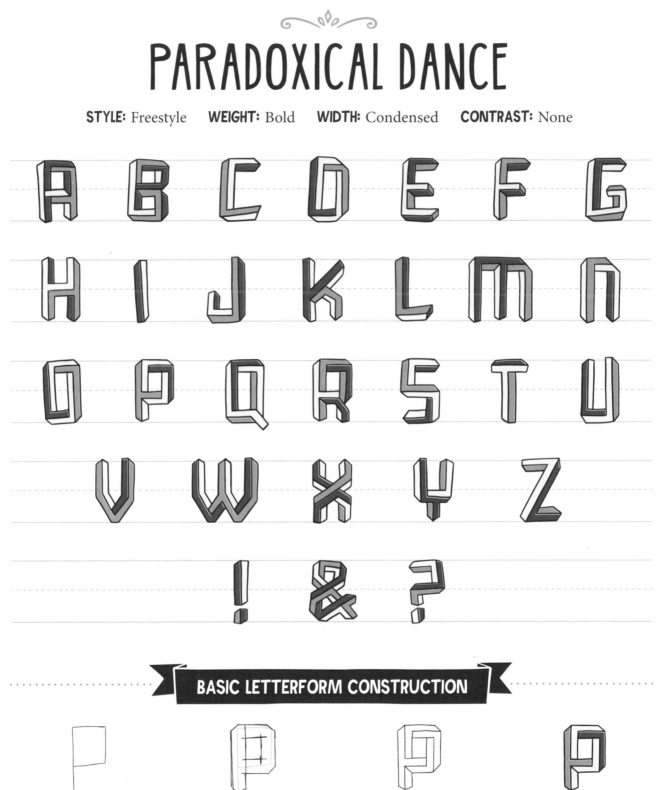

BASIC LETTERFORM CONSTRUCTION

Begin with a basic wireframe. Keep it simple as it will serve as a guide in future steps.

Start by drawing the stem of the letterform, followed by the bowl shape. Angle the ends of the strokes.

Add inner lettering dimension, and be sure to take your time working it out, as this letterform can be visually deceiving.

Trace over your refined sketch with black ink. Use a bright color palette of cyan, magenta, and yellow.

LETTERING COMPOSITION

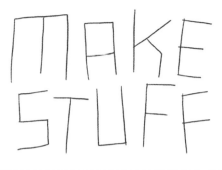

1 WIREFRAME

Draw a simple wireframe. Stack two words on top of one another, and capture the basic angular characteristics of this alphabet.

2 ROUGH SKETCH

Roughly sketch out each letterform over your wireframe. Focus on building out the thickness of each letter, and maintain the angular style of each letterform.

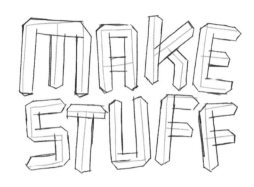

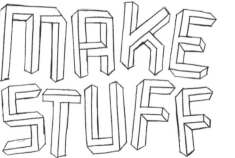

3 REFINE SKETCH

Once the rough sketch composition is in a good place, start to work out the inner lettering dimension. This alphabet can be a bit of a visual paradox, so take your time when working out each letterform detail.

4 COLORIZATION

To colorize your artwork, trace over your sketch with ink. Use a simple color palette of green, red, and yellow on a black background.

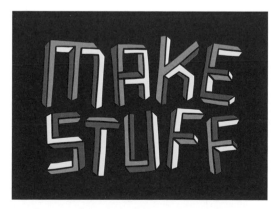

YOU GOT SLIMED

STYLE: Representational **WEIGHT:** Bold **WIDTH:** Condensed **CONTRAST:** Light

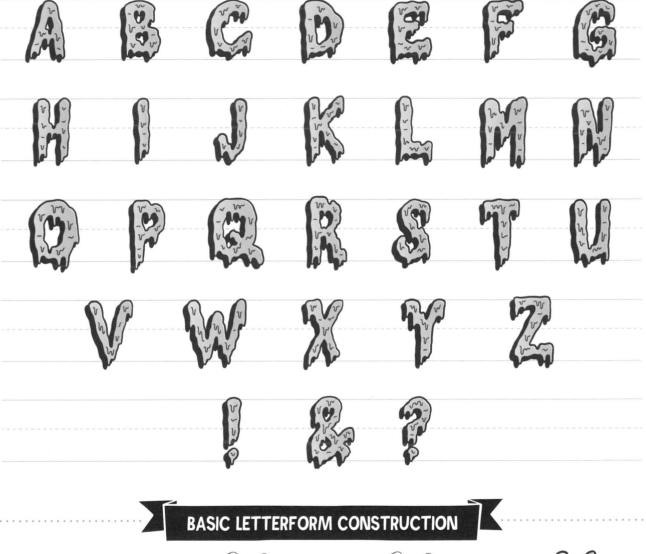

BASIC LETTERFORM CONSTRUCTION

Begin with a basic wireframe. Keep it simple, as it will serve as a guide in future steps.

Draw an organic, uneven shape around your wireframe, as shown above.

Add some dripping edges to each stroke, as well as some drip-like inner letter detailing.

Trace over your refined sketch with dark purple ink. Add a drop shadow and use a yellow and green gradient to color the inside of the letterform.

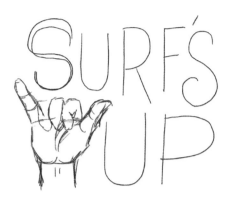

1 WIREFRAME

Draw a rough sketch of a hand doing a "hang loose" sign; then add a basic wireframe around it. Keep this lettering and illustration loose.

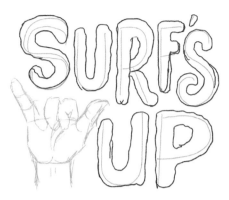

2 ROUGH SKETCH

Roughly sketch out each letterform over your wireframe. Focus on building out the thickness of each letter, and be sure to use organic, uneven styling. Allow some letters to be thicker or thinner than others to create contrast.

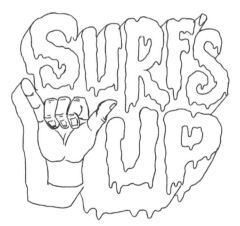

3 REFINE SKETCH

Once the rough sketch composition is in a good place, refine the linework. Start by drawing the hand with cleaner lines. Style each letter according to the featured alphabet on page 162. Finish with a shadow around the entire composition.

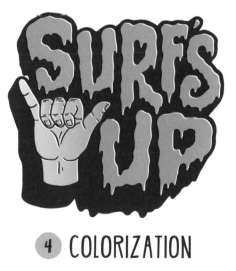

4 COLORIZATION

To colorize your artwork, trace over your sketch with ink. Use a blue and green gradient for the letters and a yellow and orange gradient for the hand illustration.

FLOAT ON

STYLE: Representational **WEIGHT:** Bold **WIDTH:** Regular **CONTRAST:** Light

BASIC LETTERFORM CONSTRUCTION

Begin with a basic wireframe. Keep it simple, as it will serve as a guide in future steps.

Draw rounded linework around the wireframe. The style should have an inflated appearance.

Add glossy accents in a few different spots on the letterform.

Trace over your refined sketch with a black outline. Use magenta to color the inside of the letterform. The glossy accents should stay white.

Lettering Alphabets & Artwork

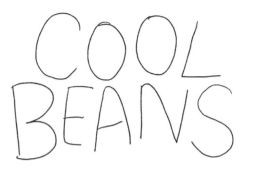

① WIREFRAME

Draw rounded wireframes to mimic the characteristics of the featured bubble like alphabet on page 164.

② ROUGH SKETCH

Roughly sketch out each letterform, keeping your lettering loose and free. Use a round, inflated look to emphasize the balloon theme. To make your lettering composition more dynamic, allow letters to overlap.

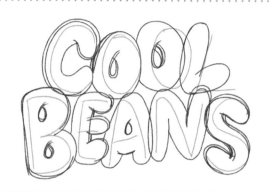

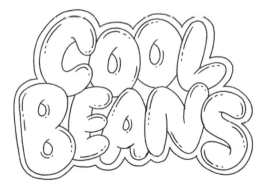

③ REFINE SKETCH

Once the rough sketch composition is in a good place, refine the linework. Add an outer stroke around the entire composition, as well as some linework inside each letterform to give it a three-dimensional look.

④ COLORIZATION

To colorize your artwork, trace over your sketch with ink. Add some additional inner patterns to your bubble lettering, such as stripes and polka dots. Use a bright color palette.

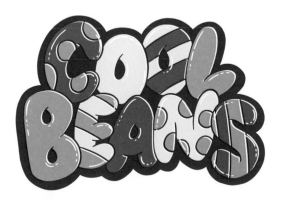

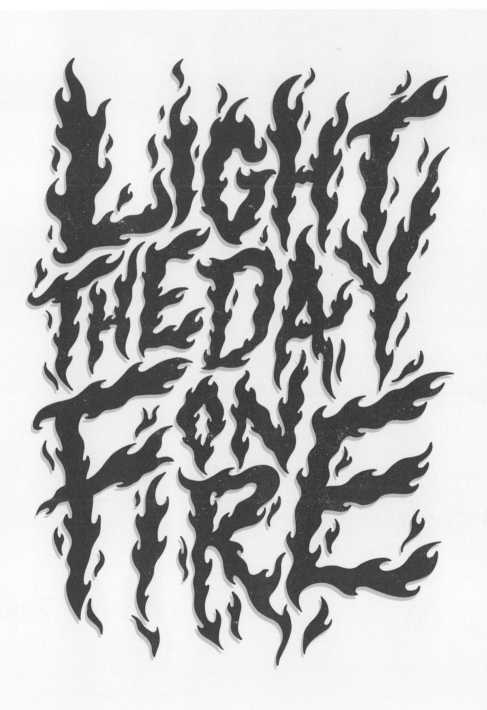

▲ Above
Light the Day on Fire
By Jay Roeder

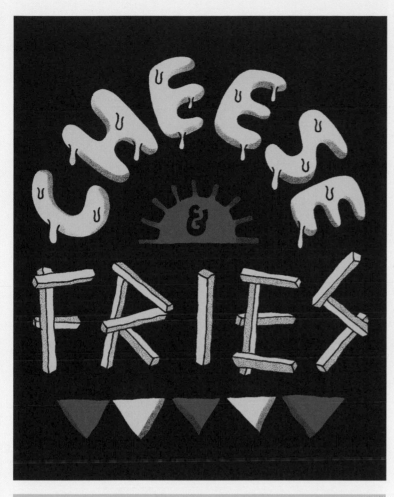

◄ Left
Cheese Fries
By Tatak Waskitho

▼ Below
Yes Yes Y'all
By April Moralba

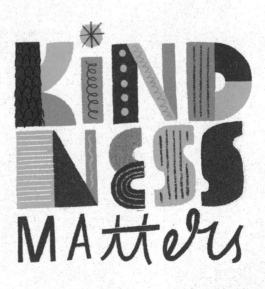

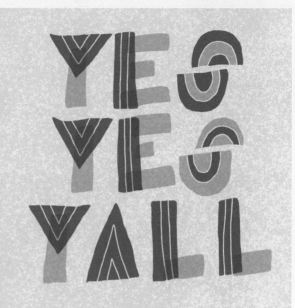

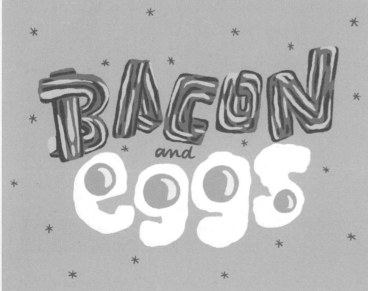

▲ Above
Kindness Matters
By Loz Ives (Idle Letters)

▲ Above
Bacon and Eggs
By Shauna Lynn Panczyszyn

Decorative Alphabets

167

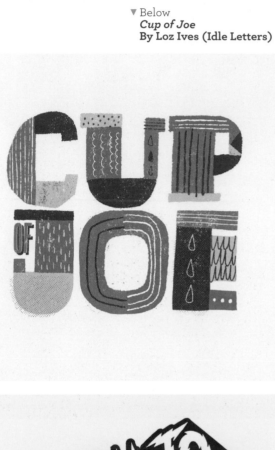

▲ Above
Chill Vibes Hard Times
By Shauna Lynn Panczyszyn

▲ Above
Fresh to Death
By Jay Roeder

▼ Below
Freestyle Alphabet
By Jay Roeder

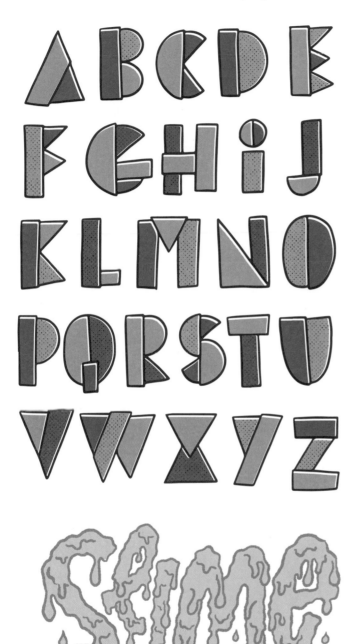

▼ Below
Salt, Pepper, Ketchup
By Kristen Herman

▲ Above
Slime
By Shauna Lynn Panczyszyn

▲ Above
Share Love
By Matthew Taylor Wilson

169

▲ Above
Grow or Die
By Joel Felix

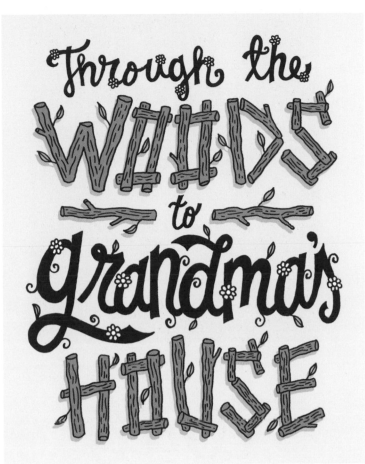

▲ Above
Grandma's House
By Jay Roeder

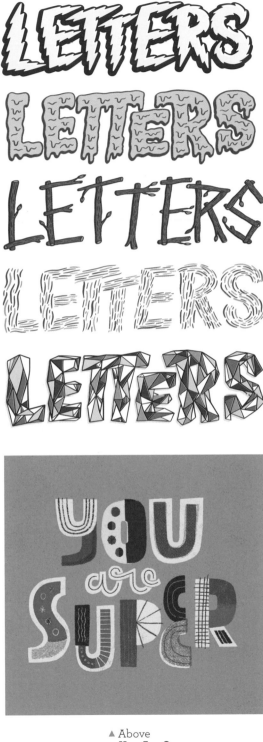

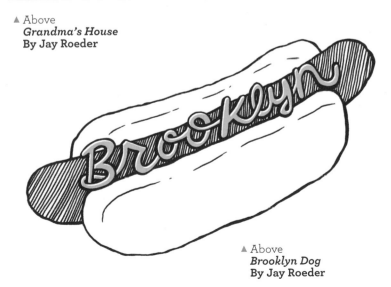

▲ Above
Brooklyn Dog
By Jay Roeder

▲ Above
You Are Super
By Loz Ives (Idle Letters)

Decorative Alphabets

171

▼ Below
Stick Together
By Loz Ives (Idle Letters)

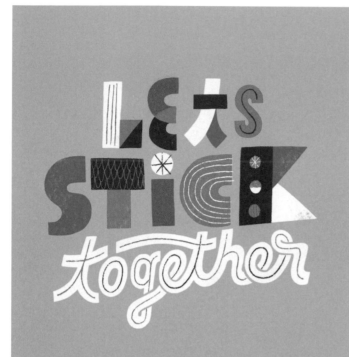

▼ Below
Be Flossin'
By Jay Roeder

▲ Above
Chocolate Scotcheroos
By Shauna Lynn Panczyszyn

▲ Above
Draw for Donuts
By Jay Roeder

▲ Above
Fired Up
By Jay Roeder

ABOUT THE AUTHOR

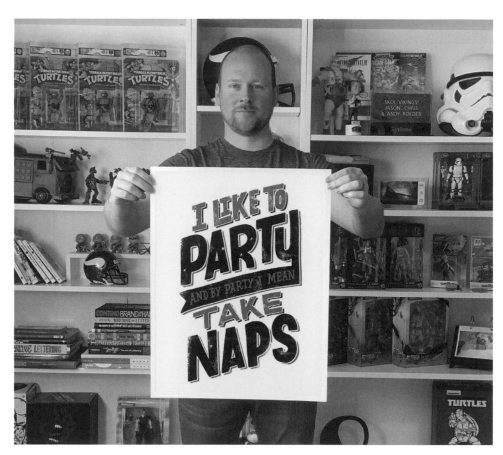

Jay Roeder is a hand-lettering artist, illustrator, and author based in Minnesota. He works in a studio out of his home alongside his pugs, who sit on his desk while he procrastinates, drinks coffee, and does work—sometimes. Jay graduated from Sacred Heart University in 2006 with a double major in graphic design and illustration. He started his career at several of the top agencies in the country, establishing a solid foundation of knowledge and skills before going out on his own in 2011.

Jay's work has been featured and sold by such companies as National Geographic, Hilton, American Greetings, Ray-Ban, Nike, and Facebook. His style blends playful lettering with retro thematics and bumper sticker humor. *Lettering Alphabets & Artwork* is Jay's second book.

To learn more about Jay and his current projects, visit his website or follow him on social media:

JAYROEDER.COM | **@JAYROEDER**

ACKNOWLEDGMENTS

I wouldn't be in the position I am today without the support and guidance of many different people along the way. I would like to thank the following people who helped make *Lettering Alphabets & Artwork* possible:

Lark Crafts and BlueRed Press, for believing in me and weaving everything together to help bring my second book to life. I am so proud of what we have done.

Nikki, for being the most unbelievable wife a guy could ask for. You make sitting around in sweatpants and watching horrible natural-disaster movies and murder mysteries enjoyable. I look forward to many more years of sushi and travel with you. I love you.

Mom, for always encouraging me to dance. You have always pushed me to pursue my creative passions, and as a result I have made a career out of it. I am truly happy, and you have a lot to do with that.

Dad, for always believing in me. When I contemplated going out on my own, you were behind me from day one. I have always confided in you for personal and career advice, and I want to thank you for that.

Chris and Andy, the experiences we've shared are the sources of so much of my creative inspiration. You are not only my brothers, but also my best friends.

ALSO AVAILABLE

Pair *100 Days of Lettering* with *Lettering Alphabets & Artwork* for the ultimate combination of hand-lettering exercises and inspiration you can refer to again and again!

When it comes to hand lettering, practice makes perfect! With 100 exercises divided into ten sections, this workbook offers a fun and friendly way to improve your lettering techniques every day. Each section focuses on building a particular skill or exploring a design application. Learn how to form letters, pair different lettering styles, and design motivational quotes. As you work on these beautiful full-color pages, featuring the striking artwork of author and illustrator Jay Roeder, you'll find plenty of ideas and encouragement to help you develop your own unique style.